Music in Art
Through the Ages

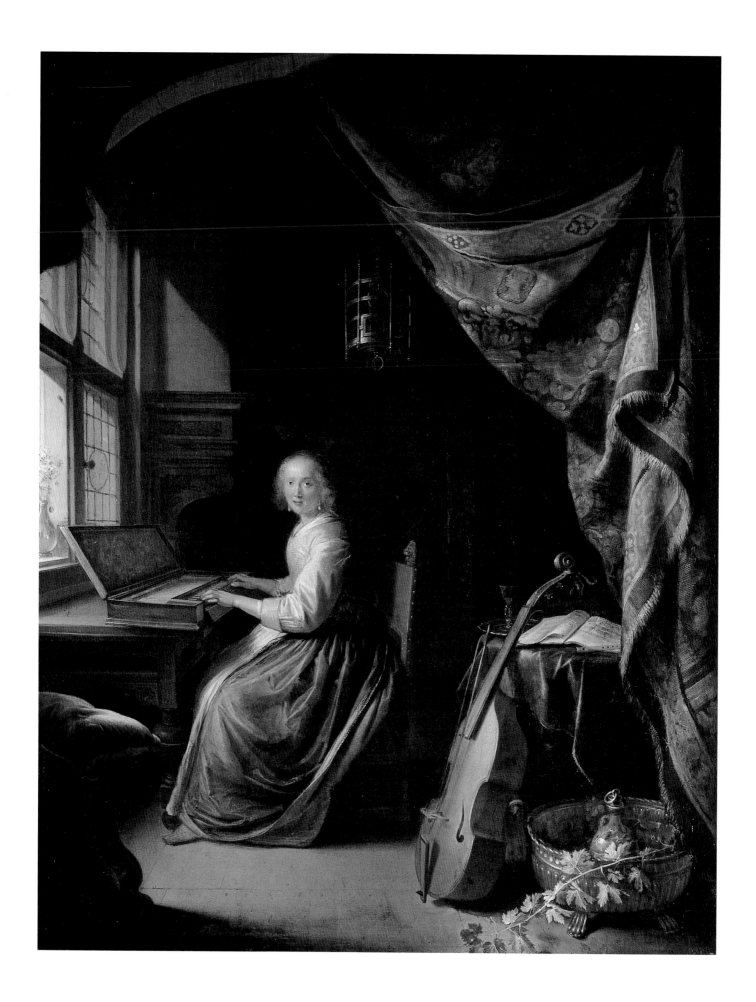

Tom Phillips

Music in Art
Through the Ages

Prestel

Munich · New York

Jacket illustration:
Caravaggio, *Lute Player*, c.1594 (detail). Hermitage, St Petersburg; see p. 90
Frontispiece:
Gerrit Dou, *A Lady Playing a Clavichord*, c.1665, oil on panel. Dulwich Picture Gallery, London
Book cover:
Tom Phillips, *Last Notes from Endenich*, 1974; see p. 121

© Prestel-Verlag, Munich and New York, 1997
© of works illustrated by the artists, their heirs and assigns, except in the following cases:
Josef Albers, Arman, Giacomo Balla, Joseph Beuys, Georges Braque, Johannes Itten,
Augustus John, Wassily Kandinsky, Paul Klee, René Magritte, Gabriele Münter, Leonid Pasternak,
Tom Phillips, Niki de Saint Phalle, Arnold Schoenberg, Walter Richard Sickert, David Smith,
Jean Tinguely by VG Bild-Kunst, Bonn 1997; Salvador Dali by Demart pro arte B.V./VG Bild-Kunst,
Bonn 1997; Henri Matisse by Succession H. Matisse/VG Bild-Kunst, Bonn 1997;
Pablo Picasso by Succession Picasso/VG Bild-Kunst, Bonn 1997.

Much of the present work has been adapted from a series of articles
appearing initially in the *BBC Music Magazine*.

The Author and Prestel wish to express their thanks for the invaluable help
given by Sunita Sharma Gibson concerning the picture research.

Prestel books are available worldwide.

Please contact your nearest bookseller or write to either of the following addresses
for information concerning your local distributor:
Prestel-Verlag, Mandlstrasse 26, D-80802 Munich, Germany
Tel: +49-89-38 17 090; Fax: +49-89-38 17 09 35
e-mail: prestel@Compuserve.com
and 16 West 22nd Street, New York, NY 10010, USA
Tel: +1-212-627-8199; Fax: +1-212-627-9866

Die Deutsche Bibliothek-CIP-Einheitsaufnahme

Phillips, Tom:
Music in art: through the ages/Tom Phillips.–
Munich; New York: Prestel, 1997

Designed by Heinz Ross, Munich
Typesetting by Sheila de Vallée, London
Colour separations by Repro Line GmbH, Munich
Printed on acid-free paper 'LuxoMatt', 150 g/sm,
Printed and bound by Passavia Druckerei GmbH, Hutthurm near Passau

Printed in Germany
ISBN 3-7913-1864-0

Contents

Introduction
7

Fifty Encounters Between Art and Music
From the Cyclades to Endenich
21

For
Fiona

Introduction

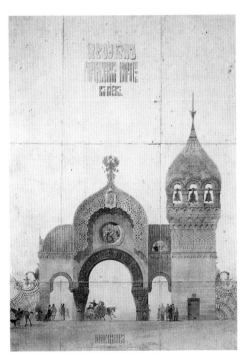

Victor Hartmann (1834–1873),
The Great Gate of Kiev, c. 1859, watercolour

The artist of course is not quite the drudge that Collam's hero makes out. He can in his turn pity music for needing the repeated midwifery of performance to bring it about with all the risks of distortion that such mediation entails.

Music is part of the fabric of life in ways that formal art cannot be. In the celestial world non-stop music-making seems to be the order of the eternal day while, in the life below, whether in court or tavern, out in the groves of Arcady or at a peasants' merrymaking, little in social existence takes place without the participation of musicians. Even the silent still-life seems barely able to manage without a musical presence in the form of a violin or guitar.

There is not, as Vellinger suggests, too much by way of reciprocation. Occasionally an operatic narrative requires the presence of a fictitious painter (*Tosca, La Bohème, Lulu* etc.) and a whole opera can indeed revolve around a historical artist as in Berlioz's *Benvenuto Cellini* or the epic drama that Hindemith makes of the life of Grünewald in *Mathis der Mahler*. Yet not too much painting or sculpting is done in these since love, intrigue and death are better spectator sports. Opera still gets the best of any deal, for its producers and designers cavalierly plunder the work of artists from Poussin to Beckmann for the aesthetic flavours of their productions.

A more felicitous dialogue between two artists and a composer carried on across the long divide which separates the eighteenth and twentieth centuries is the case of Stravinsky's opera *The Rake's Progress* (1951) based on Hogarth's engravings (after his own paintings of 1735). This remarkable collaboration between Stravinsky and his librettist W. H. Auden (not forgetting the long dead painter) only received its definitive stage form when David Hockney returned it to the world of engraving in his brilliant sets for the Glyndebourne production of 1975. The enlarged cross-hatching and predominant black and white cut-outs made the stage a living print, the exact foil to Stravinsky's neo-classical score and Auden's mannerist rhymes.

With a few successful exceptions from Rachmaninov's *Isle of the Dead* after Böcklin's evocative masterpiece to Mark-Antony Turnage's recent tone-poems inspired by the paintings of Francis Bacon, good art has proved only a sporadic inspiration for composers. This can be an uncomfortable genre as witness the lurid versions of Botticelli made by Respighi. Moussorgsky's is the better strategy in that he uses the work of Hartmann, a minor artist, on which to improvise his *Pictures from an Exhibition* (which includes of course a *Promenade*, music's only tribute to gallery-going). When one looks at the original painting of say the Kiev Gateway, a pleasant but prosaic watercolour, it seems worlds away in scale and ambition from the mighty storm and clang of *The Great Gate of Kiev*.

We play such a trick in reverse when we imagine the music being performed in a picture. Not being able to hear the lute that is plucked by one of Caravaggio's ephebic friends or the sounds that Vermeer's demure ladies produce at their virginals we tend to conjecture seductive melodies, scales as even as a string of pearls. To be realistic one must guess that wonderful art was often made out of mediocre music.

Debussy has the subtlest device of all. Referring to vague genres like 'watercolour' or 'etching' he allows the hearer to supply the absent picture, to sketch in the details and then sit back to admire the beauty of it in his mind's eye. Although he loved the paintings of Monet in particular he himself did not at all enjoy being dubbed an Impressionist: how after all could an 'impressionist' contemplate an opera on an almost Wagnerian scale based on *The Fall of the House of Usher*? Nonetheless, whatever Debussy seems to be describing, be it an aspect of nature, a crowded scene or a piece of japonaiserie, Monet's rich mirages are the closest visual correlative. Monet's paintings themselves, from the cathedrals drowned in light to the vast notations of water lilies, drew nearer and nearer to the condition of music as time went by. When he died in 1926 Impressionism was a more heroic label than Debussy could have imagined.

As painting moved towards abstraction it began to gather the freedoms it had so long envied. Released from the seeming tyranny of mere description its relation to its sister art now made sense of their centuries of language-swapping. In the manner of Debussy's evocative artistic titles, Whistler's designation of 'Nocturnes' to describe his mood pieces had a musical source, and he would (as Klee and Kandinsky were to do later) refer to the key in which a picture had been painted. As composers speak of their orchestral palette so painters talk of rhythm and tonality in their pictures. Abstraction, however, was not to prove the universal Esperanto of art that critics had once predicted: luckily art does not proceed in a linear way towards a goal. But it had nevertheless staked out this common terrain and would never lose its possibilities.

The moment of closest approach between the two creative disciplines came perhaps in that final explosion of Abstract Expressionism in New York, a heady time of frontier experiment when composers such as Feldman and Cage together with painters like Rothko and Guston felt that they were striving with a common purpose. Morton Feldman often spoke of an epoch of mutuality when he could claim to be setting Rothko to music and hear the painter agree that he had been transcribing Feldman in paint.

Many such developments have not found their way into these pages for they elude illustration. Although there is no system or program to unify this gathering of what were, in their first form, a series of monthly articles for the *BBC Music Magazine* (a general journal of classical music), there is a natural tendency to concentrate on the art and music of the west. Despite an occasional glance at prehistoric times and, out of personal interest, to Africa, the dominant subject matter comes from the music and art most generally known and which therefore do not call for painful exegesis. Relevant material streams off in all directions from that narrowed world.

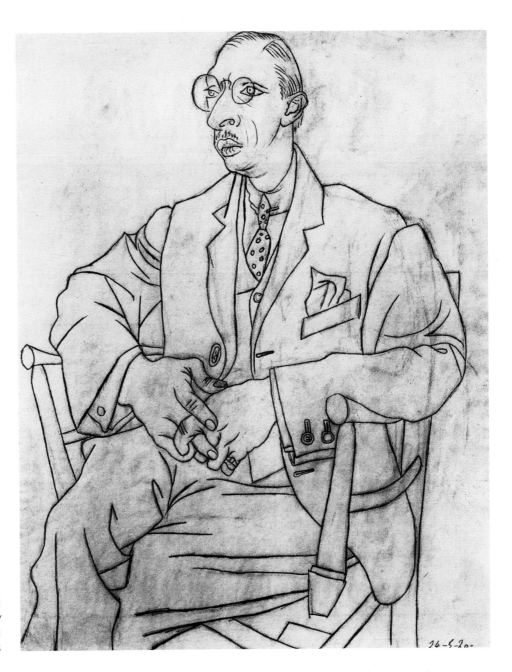

Pablo Picasso (1881–1973)
Portrait of Igor Stravinsky
1920, drawing
Picasso Museum, Paris

Even if one tried to be comprehensive one could only be so in the certain knowledge that somewhere at this minute an artist is finishing a picture that would fit well into these discussions, or that in a distant place an archaeologist is just now releasing from the earth yet another mute testimony to the liveliness of the music of ancient cultures.

The composer should be, as highest in the hierarchy of music, the heart of the matter. Wagner was painted by artists as different as Lenbach and Renoir, and Beethoven (with the posthumous aid of his death mask) gave birth to innumerable images which cumulatively leave us with the misleadingly one-dimensional impression of a brooding creature, all scowl and clouded brow; the ultimate ikon of genius.

The most indefatigable of portrait sitters was, paradoxically, one of music's uglier ducklings. Reflecting his central role in the cultural life of so many countries, Stravinsky seems to have been painted by every painter

and photographed by every photographer. In a competitive field the easy victor is (unsurprisingly) Picasso who in his dazzlingly parsimonious drawing of 1920 made one of the century's redefinitions of the idea of a likeness. His apparent certainty of draughtsmanship, as if the artist had been able, in a single unaltered line, to lassoo the whole volume and presence of the composer, is deceptive: buried under the final almost arrogant outline is a whole series of tentative and erased changes of mind. This enactment of the process, with paper or canvas as a kind of battlefield in which error is outwitted by decision, is unique to art. Music, except to the scholar who has searched through manuscripts and composers' sketchbooks, leaves no trace in the end product of the struggle of its making.

But the composer is not usually the focus of the artist's attention. It is the player who takes centre stage in countless pictures; for he or she is doing something, not just sitting there looking vacantly inspired. The instrument can be an invaluable prop (in both senses) to a composition. It can give animation to stillness and provide the beginnings of a narrative. Most of all it can set the air of a picture alive with sound, can vivify its space. The world of performance is also one where women have known a proper equality for longer than in almost any other pursuit. Some feminist critics, preoccupied with the 'male gaze', might point out that the pres-

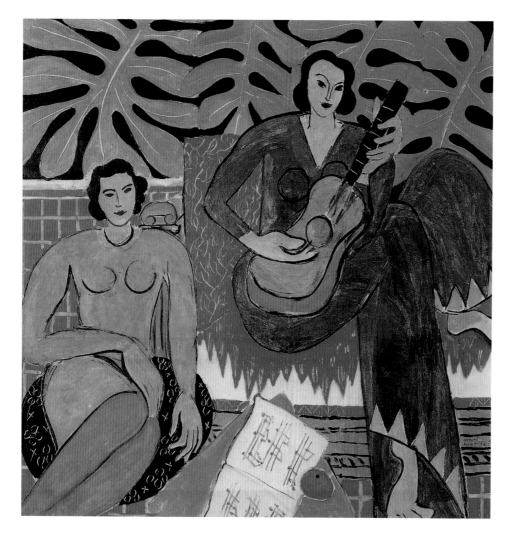

Henri Matisse
(1869–1954)
Music
1939, oil on canvas
Albright-Knox Art Gallery,
Buffalo, N.Y.

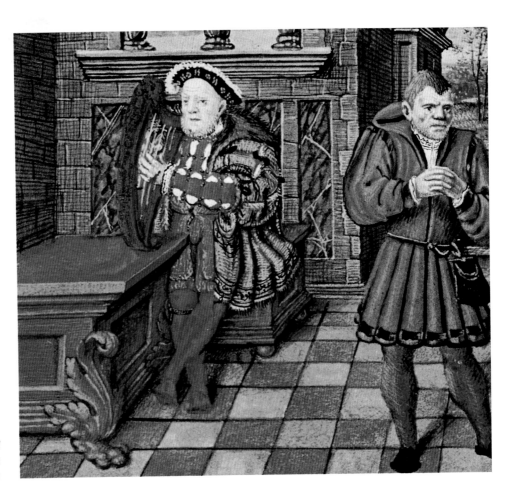

ence of an instrument serves as just another alibi for treating a woman as an object. This is luckily disproved in nine cases out of ten by the forceful personalities of the women musicians we meet with: either they are (like *Madame Suggia* [p. 107]) sources of energy within the picture or they may gaze back with a confidence to match that of painter or observer (as do the *Linley Sisters* [p. 41]). Matisse's *Music*, without the leavening anecdote of guitar and sheet music, would be almost frighteningly confrontational: instead we are on conversational terms with two strongly self-contained women. Their poise and substance is abetted by the masterly contrasts in their surroundings where rhythmic patterns and tonal oppositions serve, as we are drawn into them, as surrogates for absent sound.

Music offers a story line to link all kinds of groupings, bonding individuals by shared activity. Zoffany's great family gathering (p. 114) without its musical motivation would be left to glare or grin individually towards the man at the easel (as such assemblies now do to the camera). Music can give gaiety or gravitas to the social activities of humdrum folk as it can soften the stiff life of the courtly with humanising occupations. It can even give grace to cruel kings. Henry VIII is not alone among royal harpists but, unlike King David (p. 67), the English monarch (composer it is said of 'Greensleeves') needs all the help he can get in terms of public relations.

The harp by tradition is the instrument without which the largest of all orchestras, the heavenly host, would be incomplete. While hardly professional the great band of angels cannot (if only by virtue of incessant prac-

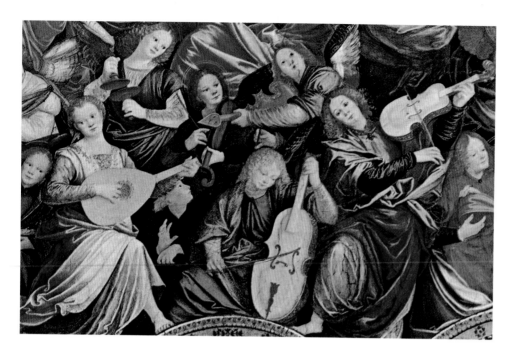

tice) be labelled amateur. We see them in art mostly in chamber groups or
as soloists. At high moments of glory in biblical legend we behold the
whole ensemble, often blurring away into infinity. The record for clearly
differentiated members of a celestial orchestra must be held by Gaudenzio
Ferrari whose astonishing ceiling features a hundred or so instrumentalists
and singers, together with twenty-nine handclapping cherubs: and all for
an audience of One. It is a prodigious feat of articulation and organisa-
tion. As well as being a supremely wrought piece of decoration it gives us
a more or less complete inventory of the musical forces characteristic of the
sixteenth century. In this great harmony, with the exception of a couple of
flautists (who are nonetheless poised for action), all are busy blowing and
bowing, striking and plucking to make a mighty chord that would satisfy
Mahler himself.

To descend from the massed angelic forces to the most minimal of sub-
lunary groups we find at the opposite end of the scale the domestic music
lesson. This (with certain solemn exceptions like Vermeer [p. 100/101])
tends to be the ideal device for the pictorial encounter of young lovers. The
unchaperoned meeting, especially indoors was a virtual impossibility in
earlier bourgeois life. Only the music-master was on a par with priest and
doctor in freedom of access (while not sharing their vows or professional
etiquette). Intimacy and proximity were his on a plate: the duet stool, the
hand guiding a hand, the reaching over to turn a page, the help with
posture, must have occasioned many a maiden's first blushful moment of
arousal. Fragonard, always an exquisite painter but willing to please a
large clientèle with a taste for the softly pornographic, shows us a hot
moment in the making as the teacher's attention wanders from keyboard
to cleavage. Here the feminist critique does have a point though of course
it is wasted on the desert air of retrospection.

Independently of the players, the forms of instruments have always
attracted the artist. The harp has a six thousand year old history of repre-

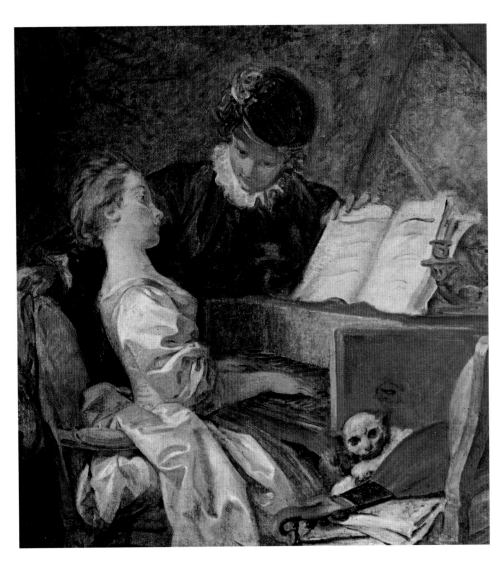

Jean-Honoré Fragonard
(1732-1806)
The Music Lesson
1760–65, oil on canvas
Louvre, Paris

sentation and still remains the emblem of a bardic time when literature and music were as one. The guitar (with its ancestors) has a unique social breadth of appeal and can turn up in court or gypsy camp, yet it is the lute that is the canonical instrument of high art. Painters are not only fascinated by its sensuous femininity of shape but are nicely tested by the problems of draughtsmanship it presents. For such a poetic object it offers teasing problems in perspective, often helped (or complicated) by its frequent decorative stripes or patternings.

In the eighteenth century this role was gradually taken over by the violin which, in its earlier manifestations as a viola da braccia (as played by Apollo on Raphael's *Parnassus*), had been more than merely waiting in the wings. With its equally feminine but more elaborate set of curves and convexities the violin became for the painter the instrument of instruments. Even that most self-proclaimedly unmusical of artists, Picasso, having borrowed it as a motif from Braque, could not resist putting it through the whole mill of Cubist anatomisation (p. 88 and 117). If any doubt the erotic charge of the violin's shape they need only glance at Man Ray's elegant and economical adaptation of a postcard which he entitles *Violon d'Ingres* in homage to that best known of amateur violinists and cool poet

13

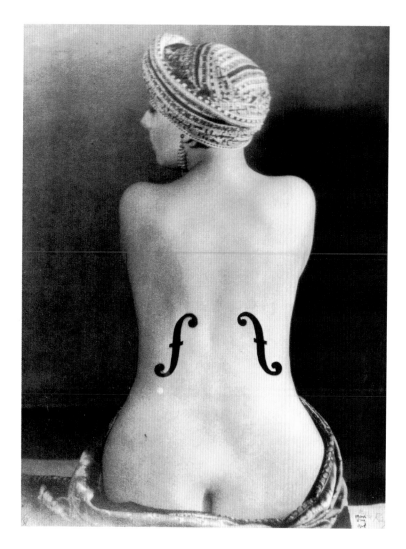

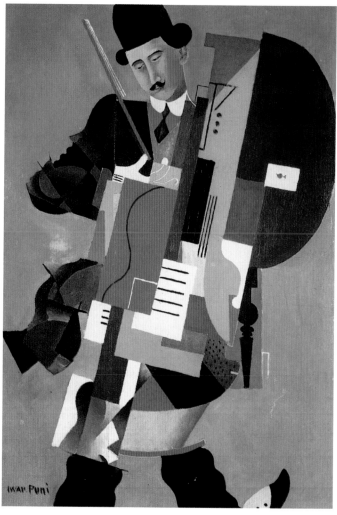

of luxurious flesh. Whether the severe J.A.D. Ingres would have approved of such a gesture this treated nude is one of Dadaism's most memorable jeux d'esprit.

Other instruments make their appearances when occasion demands: without his horns and trumpets the king cannot ride to hounds or battle. The pastoral encounter is incomplete without its slender pipes and revelling peasants cannot properly thump the ground without the drum's beat and the bagpipes' drone. A chance friendship with an artist may bring a less-favoured instrument to the fore as in Degas' tribute to a bassoonist (p. 81). One player who is not going to be found wanting, whatever the gig, is Ivan Puni's all-purpose musician, a bowler-hatted and bespatted figure who, though dressed for the city, has a Cubistic compendium of instruments about him ready to play (as well as the ace of spades). He who is paid the most, however, has no instrument at all. The conductor, in the absence of the music he creates, can look like a mad gesticulator. It takes an artist with a sense of theatre and atmosphere like Sickert (p. 87) to make sense of his lonely figure.

There are indeed painters for whom music is a career-long obsession. Raoul Dufy's first substantial painting, heavily influenced by the Degas picture mentioned above, was of the limelit orchestra of the Opera House

Man Ray (1890–1976), *Le violon d'Ingres*, 1924, gelatine silver print.
J. Paul Getty Museum, Malibu

Ivan Puni (1892–1956), *Synthetic Musician*, 1921, oil on canvas.
Landesmuseum Berlinische Galerie, Berlin

14

at Le Havre. He went on revisiting this theme to the end of his life, often depicting, in his knowingly sketchy style, the incidents that others have overlooked in their search for the picturesque. Every concertgoer has seen this little landscape of instruments abandoned by the players as they go off for the interval (leaving one behind; a teetotaller or an oboist who has to prepare a reed?) yet only Dufy thought it worthy of perpetuation and caught its silent poetry. This witty chronicler of musical life painted more pictures of music and its makers than any artist in history. His oeuvre is much rifled by the designers of CD covers, who use and re-use his colour-saturated pictures (such as those single violins which appear as homages to Bach and Mozart and prominently include their resonant names).

Some artists on the other hand may deal with a musical subject only once or twice in their entire output as is the case (unusually for a Dutchman) with Rembrandt (p. 67). Turner, like Constable before him, became a reluctant painter of anything but landscape. In his fifties, however, while staying at Petworth or East Cowes Castle in the south of England he risked the occasional interior with figures. One can immediately see why he usually desisted. The abstract approach that the taste of the time had learned to accept in landscape would not have been acceptable in figure painting. In the daring *Music Party* (painted round about the time of Beethoven's death) he is among friends in the fantasy castle of the architect John Nash. The pianist might well be Mrs Nash since she was proficient enough for J. B. Cramer to dedicate to her his divertimento *Midsummer Day*.

Such a piece would certainly match the weather which the inveterate painter of nature has brought into the room with him together with the luminosity of sky and sea, making the figures shimmer into insubstantiality. More like a memory than an event it is an apparition such as Proust would later summon, triggered by a tiny phrase of music. Such a potential of gesture and atmosphere was (with the possible exception of Ryder [p. 69]), to lay dormant for over a hundred years until the bright days of Abstract Expressionism in America.

Raoul Dufy (1877–1953), *Interval*, 1945, oil on canvas. Private Collection, Mexico City

Raoul Dufy, *Red Violin*, 1948, oil on canvas. Musée National d'Art Moderne, Centre Pompidou, Paris

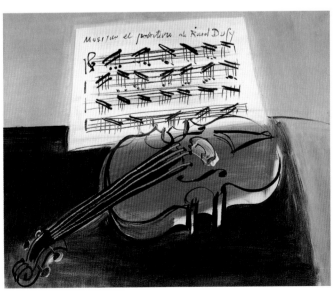

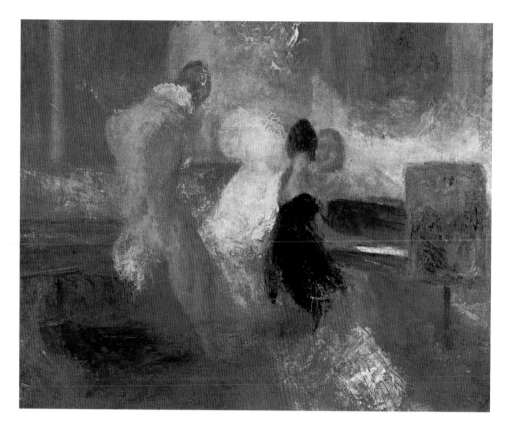

The sense of the whole surface of a picture being an acoustic for the sound of imagined music is a feature also of the enigmatic canvases of Watteau. His melancholy soloists inhabit a fragile world. In the stately Dulwich Picture Gallery built by Turner's other architect friend John

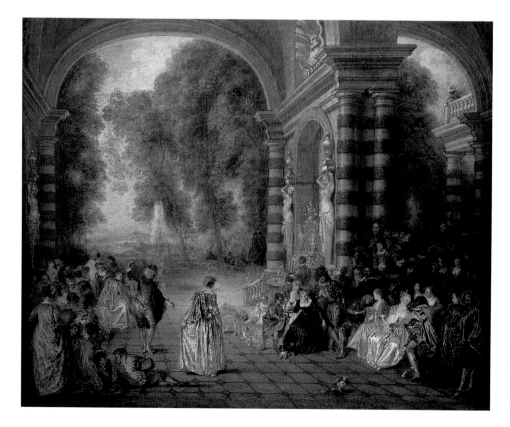

Soane and full of pictures of actors and musicians (cf. p. 2, 40, 41, 57), is one those magical paintings where the boundaries of art, theatre, music and dance are scarcely to be discerned. Its rarefied air tingles with the distant noises of nature and artifice. One imagines a light breeze and the fountain's faint splashing but does not at first notice (except for one resting with a guitar) the musicians, a lively quintet gathered in the shadow of an arch. Everyone in the picture has a role rather than an existence. Their faint pageant will vanish at a touch into Prospero's thin air. It is as if Watteau's short life was led amongst a troupe of strolling players who sought out such never-never lands of palace and park, settled upon them for a while and resumed their graceful and delicately accompanied mummery.

In times and countries where music has been the medium of darker magic (whose last trace in the developed world is the association of the devil with the violin) instruments are invested with special powers and may take on animal or human form as in the remarkable thumb piano (mbira) from Zaire (cf.p. 33). Such transformations are enriched by ambiguity. In the case of the robust and headless Makonde instrument of

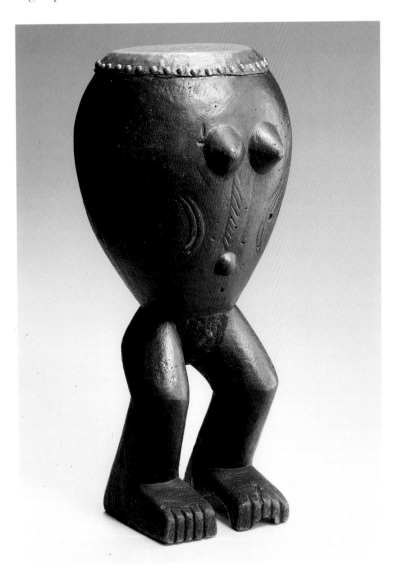

Unknown Makonde artist,
Tanzania/ Mozambique
Drum (likuti)
late 19th or early 20th century
wood, leather, hair, copper nails
W. and U. Horstmann
Collection, Switzerland

dance and message, has the drum become a woman, or a woman the drum? It is in any event a sculpture in its own right whose proud poise and earth-rooted stance lend weight to its wit.

Fascination with other worlds gave Surrealists such as Magritte and Dalí licence to adopt the musical instrument as a motif on which to play their still unnerving variations where pianos liquefy and tubas burst into flame. Chagall in his turn produced earthier fantasies which we can now, in the perspective of literature, confidently label Magic Realism. In Chagall (for whom no roof is fiddler-free) the music-maker is a pliant creature of dreams who can finally be subsumed in his instrument. This is an image that every musician would understand. Here, a wedding scene is full of tunes whose sky-borne makers divert the party enacting the Jewish mar-

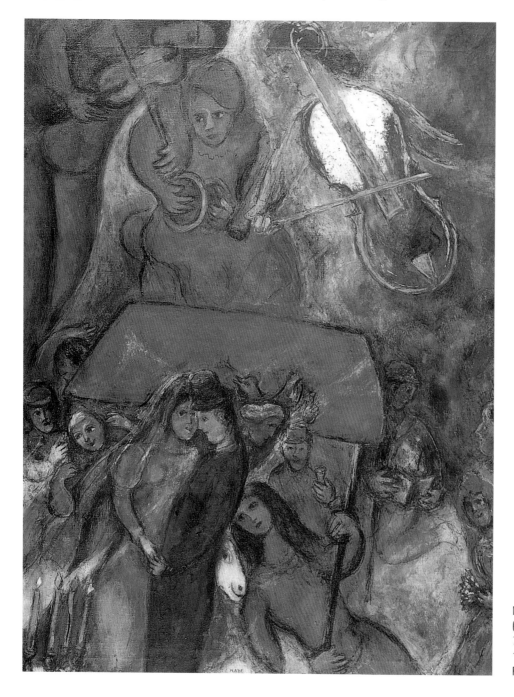

Marc Chagall
(1887–1985)
The Wedding
1944, oil on canvas
Private collection

18

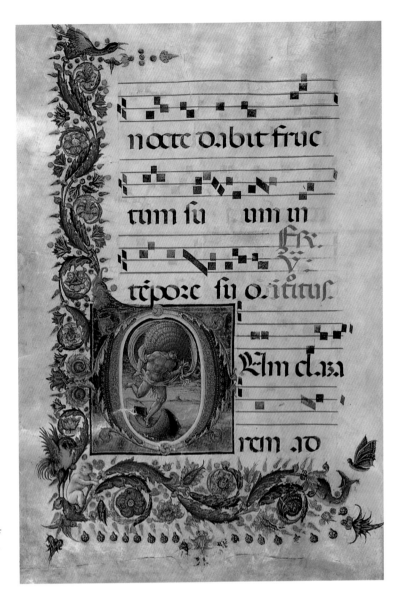

Liberale da Verona
(c.1445–1529)
*The Gradual of
the Cathedral of Siena*
c.1470–76, illumination
Cathedral, Siena

riage rites. One of the trio has indeed been transmuted into the cello that he is bowing so rhapsodically that he upstages even the inevitable fiddler.

Apart from instruments the paraphernalia and impedimenta of performance provide the artist with an invaluable repertoire of props. On a purely technical level sheet music yields much needed whites and creams among the thickets of darkly varnished wood. The various shorthands that serve to depict notes and staves in paintings, from the blank album leaf on the piano to the devoutly copied and fully playable score, would make a study in itself. In recent years the freer interchange between the arts has produced scores that are themselves graphic masterpieces. New orthographies return the art of notation in scale and complexity to the massive renaissance choirbooks whose melodic lines of roof-slate-like notes were scribed to be read simultaneously by many and at some distance. The great Gradual of the cathedral of Siena, illuminated by Liberale da Verona when in his twenties, is a prime example and the superb emblem of wind is all too appropriate for choristers as they sustain their breath up and down these tonal staircases.

The lowliest items of music's bag and baggage are not exempt from art's scrutiny, ever on the look-out for a symbolic potential. Even the humdrum music-stand (p. 48) can have its moment in the spotlight. The dead cases from which instruments have emerged can also be pressed into emblematic service by masters as various as Holbein (p. 47) or Matisse (p. 79). Painting's embrace of music has been truly comprehensive.

There can never be a book (at least one that could be lifted) that might cover the whole field of music as it makes its innumerable appearances in art. This one has neglected continents and omitted to deal with famous images. These essays nevertheless hope to chart some marking posts, familiar and unfamiliar, in such a wide terrain. There has been much pleasure gained in seeking (and seeking to understand) these rich conjunctions, which I hope prove Collam's assertion that "art is in love with music." I trust it has everywhere been apparent that I am in love with both.

Fifty Encounters Between Art and Music
From the Cyclades to Endenich

"So you think," said Rima, "that the arts were one thing in the beginning, and have gone their broken ways, merely bumping into each other in chance encounters except when welded together again by some mighty hand like your beloved Wagner."

"How gently you mock me," chuckled Vellinger as they stepped from the harmonious violin-coloured landscapes of the Picture Gallery to the green chaos of reality outside, "but precisely so. Yet there are moments of fusion to remind us of a magic past. Where better to look than in your beloved Shakespeare ... in that sad mysterious Winter's Tale...."

"You mean the scene with the statue that is supposed to be by Giulio Romano, although he never made one?"

Osborne, himself well-trained as a statue, held open the door of the Delage, but Vellinger touched Rima's arm to delay her.

"Yes, that's it," he said "and Shakespeare mentions the artist – what painter ever had a better advertisement – so that we know it is a great work of art. The spell is cast, when Paulina, facing a piece of sculpture, in a work of dramatic literature, invokes music to bring art to life. This is the pneuma, the breath, the literal inspiration. With a single line, 'Music, awake her. Strike', she restarts time itself: The characters can move towards the future again. Music has entered art by means of poetry...."

H.W. K. Collam.
Come Autumn Hand (Ch. IV)

The Bard and His Ancient Gods

Nothing precedes music. Though our first evidence of human activity (in Africa over a million years ago) is the presence of axes and tools, we can well imagine that some precursor of the work song provided the rhythmic accompaniment to their making.

One day the pattern in the brain will be found that shows all musical structures to be dormant in the infant (like strings waiting to be sounded) just as the template of language is laid out in wait for us to fit our native tongues around. Speech itself without pitch and melody is crude and robotic, only fit for chilly communications of the simplest things. Just try saying 'Music in Art' without any variations in pitch.

Thus it is no surprise that the first great masterpiece of European sculpture where the whole figure in action is fully realised represents the musician/poet.

the bard. This sculpture, though in fact no taller than the book you are reading, could just as well be a colossus dwarfing a hilltop or commanding a hazy blue bay, so grand and massive is its conception. It was carved over five thousand years ago in the Cyclades – those small Greek islands (now so popular with holiday-makers) where over the years hundreds of marble effigies have been found. This, the greatest of them, now sits in silence in the Metropolitan Museum of Art, New York, surrounded by his enigmatic contemporaries.

For me, he is the true Homeric image of an age when song and poem were one (as later they were in the Anglo-Saxon tradition, for an epic like *Beowulf* would have been sung to a virtually identical instrument). He is Homer before Homer, before, in fact, even Homer's subject-

matter, since he predates the Trojan war by almost two thousand years. We invariably make the mistake with our more recent heroes of identifying the old man with his youthful works. It was not, after all, the immemorially wrinkled Einstein of the canonical image that developed the revolutionary theories, any more than it was a bearded old curmudgeon that wrote the youthful and passionate music of Brahms. This bard is one for whom love, war and hardship are fresh in the memory. Homer was once a young man like this when he sang on the island of Chios (from which, according to tradition, he came).

As so often with instruments, the natural world is hinted at: here in the swan-like arch of the frame with its beaked head metaphorically projecting the music outwards. The whole sculpture is conceived as a series of replicating sound waves starting with the right angle of the chair which is echoed in turn by the posture of the player and the base and upright of the harp itself. This rigid progression is offset by the lyrical curve of the rest of the instrument, whose tension allows one to imagine the absent strings and their taut expectancy.

If any should doubt the wealth of imagery that unites man and music, they have only to look at the many representations of deities from the same Cycladic culture which are described even in the driest scholarly writings as 'idols of violin-like form'. It is not of course that the gods are shaped like violins, but rather that violins are shaped like gods.

We know no more about the fashioning of these figures than we know about this harpist's song. We do not know whether he has just struck the note that calls the attention of those gathered round or whether that eloquently poised thumb has just plucked the final sound of a dying cadence. His lips are sealed. Like all bards and seers he gazes blindly into space. The song is never quite ended, or eternally about to begin.

Cycladic
Idols
c. 5000–4000 BC
Museum of Cycladic
Art, Athens

Cycladic
Seated Figure with Harp
c. 3000 BC, marble figure
Metropolitan Museum
of Art, New York

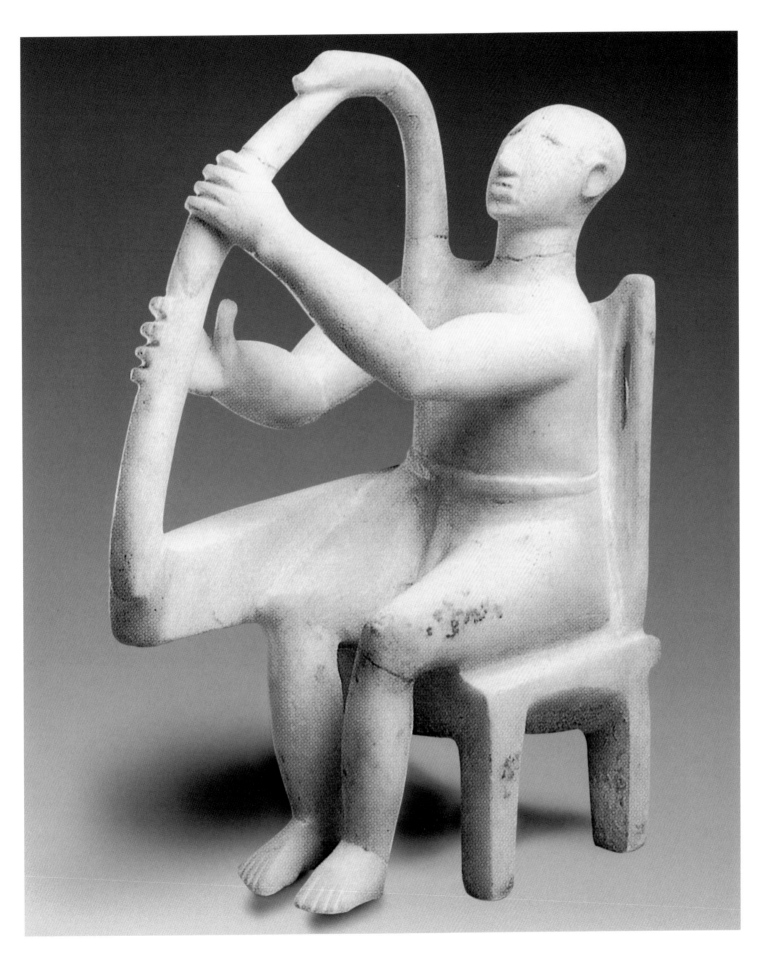

The Dark Myths of Music

Music, in ancient story, can heal or redeem. It alone can cause the snake to rise or the statue to come alive and without it rite and ceremony lack a potent ingredient. Yet for its creators, music can be also a curse: possession of its gift condemns them to servitude. Even the mortal performer, when he or she reaches the lonely peaks of excellence, stares a daily terror in the face. The two great myths of music offer no comfort and lesser ones like that of the sirens' song warn of perilous seduction.

The best known tale, of course, is that of Orpheus. Initially this is a pleasant legend of one whose pure beauty of sound could summon from burrow and lair the creatures of the wilderness. As if in an image of his harmonies they would gather together, predator and victim, captor and ruminant in a trance of peace. Trees would lean to listen and even the rocks would lend a stony ear. This golden truce of nature is itself a metaphor of that underlying harmony, the unheard song of celestial bodies in their geometric motion, the music of the spheres. Yet the part of the Orpheus story that has fired the invention of composers from Monteverdi to Harrison Birtwistle is that of the tragic separation of Orpheus from his beloved wife Eurydice and his

ill-fated quest to charm even the court of Hell with his melodies to bring her back. His life ends in isolation and he is torn apart by maddened Bacchantes: only his severed head, tossed about on the waves, lives on forever singing Eurydice's name.

Less attention has been paid to the other primal myth of music, the story of Marsyas. Opera may have shunned it because its final horror is unstageable. It has, however, been a favourite subject for painters who have seen in it an emblem of art's fatal delusion of competing with the gods.

At the beginning is a trivial instance of female vanity. Minerva finds pleasure in playing the pipes until one day she catches sight of her reflection in a pool. The distortion of her face with distended cheeks so dismays her that she throws away the pipes in disgust. The satyr Marsyas, passing by, picks them up and eventually becomes a virtuoso performer, to the extent that he challenges Apollo to a musical contest. They agree that the winner should inflict on the other whatever humiliation he chooses. With the muses forming the majority of the jury (which makes it a rigged contest from the start) Apollo prevails: only one of the judges

dissents, saying Marsyas is the better player. This is Midas whom Apollo rewards with asses' ears before getting on with the gruesome task of flaying Marsyas alive. The skin, it is said, was later hung up to view in Celaenae where, occasionally blown up as a bladder, it was used as a football by the local youths.

The main episodes of this grim tale are clearly depicted by Anselmi in what might seem to be a prototype of the comic strip but in fact harks back to an earlier Italian tradition of pictorial narrative in which time travels from one side of the image to the other (here, exceptionally, from right to left). The painter makes the duel even more unequal by modernising the instruments. The luckless Marsyas has been provided with bagpipes instead of the slender double-pipe and Orpheus has exchanged his lyre for an aristocratic ancestor of the violin: in any competition for beauty of sound one would put money on the violin to beat the bagpipes. Marsyas here is an ordinary human with no faunish hooves though, next to the gleaming Apollo, whose elegance would also swing a jury in his favour, he is still a hairy enough chap. In the background, a river winds its way through the landscape linking

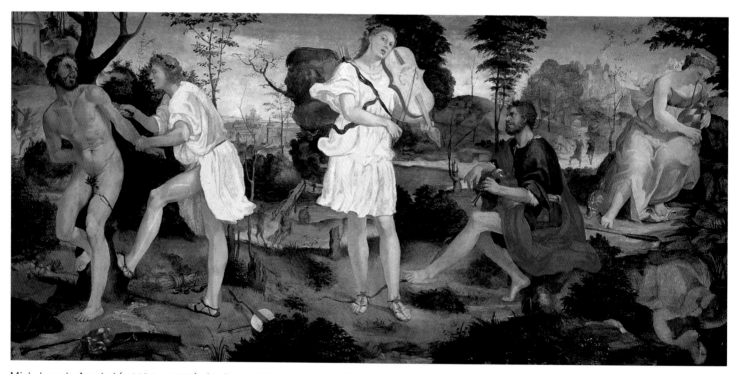

Michelangelo Anselmi (c.1491–c.1555), *Apollo and Marsyas*, c.1540, oil on panel. National Gallery of Art, Washington

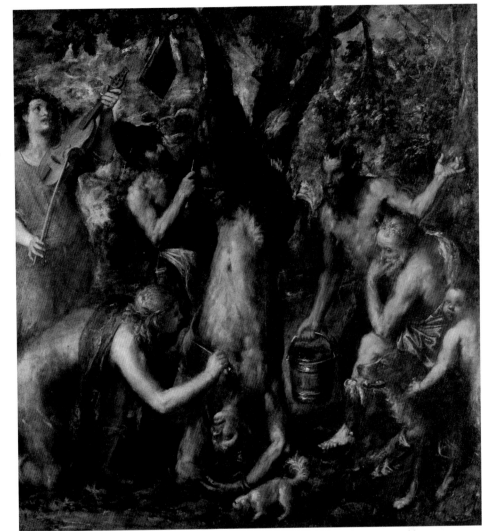

the incidents: it provides, in fact, a fourth time-frame of the saga since it is the river Marsyas formed by the tears of the satyrs and dryads who mourned their butchered friend.

But such heavy matters need a mightier hand and it is the not merely mature, but (approaching his ninetieth year) venerable Titian that we must turn to. In what may be his last major work on any scale (it is well over six feet high), Titian shows Apollo exacting his bloody forfeit with curious almost loving tenderness. Midas, ass-eared but still seeming to be pondering his verdict looks on. Marsyas as if in some parody of the crucifixion occupies the centre of the picture and hangs upside down from a tree. A second Apollo figure accompanies the torture, conflating the narrative into simultaneity. The whole canvas is alive with chevron-like limbs and despite the sombre key in which the rite is painted a tremolo of white and greys flickers over the surface comparable to the halo of strings with which Bach surrounds Christ in the *Matthew Passion*. The word Passion does not seem out of place for this solemn sacrifice and if one looks at Marsyas's face the right way up one sees that mood of triumphant agony that classical painting reserves for religious martyrs.

Titian's many worlds have come together in this summation. His love of music and his prodigious command of the language of painting join his sense of drama and mystery. It is as though his final statement about art is that Apollo and Marsyas represent the dual nature of the artist and this combination of arrogance, beauty, love, sacrifice and torture are contained within the artist's struggle.

Music has lost none of its power to unite and divide. The myths have not departed into some hazy world of cultural heritage. Music still possesses that special force to enchant, to enslave, to demonise or even to lure to death. Its battles are now at their most extreme and most polarised in far-flung camps of time and taste. Tomorrow's classics are vilified today and in the world of popular music the strife of generations has its blatant theatre. The generation that yielded (to the disgust of their elders) to despicable crooners with self-evidently lax morals soon became parents themselves. Then, suffering from the usual amnesia, they condemned in similar terms the rock and roll that made their children swoon. These in their turn are already despairing of the degenerate sirens that are giving their offspring the same unsavoury thrills. And so it goes on. The young of each age see the music they think of as their own as part of their personal identity, their membership of cult and clan, their initiation into community. One used to have to travel arduous miles to hear a music that was truly strange to one's native ear. Now such sounds may come from the window across the street. At last it is plain that music in all its disturbing variety is one of the largest consumers and providers of human energy. No wonder then that in mythology music is dangerous magic: its best makers are still sanctified or destroyed, and its performers (in some faint verbal echo of this legend) occasionally flayed by the critics.

Music for a Watchmaker

Wit is present in all great pictures. Humour, however, is a field full of nasty mines like bathos and triviality: only the most nimble artist can cross it without stumbling and it pays to come from a nation of watchmakers. It is no coincidence then that two great humorists of art came from Switzerland and were each obsessed with music. Jean Tinguely (cf. p. 62) constructed mad sound machines which exist as sculptures in their own right, and one of the sources of his inspiration was this fragile and tenuous piece of engineering by his compatriot Paul Klee painted three years before his birth.

The Twittering Machine like most of Klee's works is a miniature. Its size and delicacy match exactly the nervous trills and tiny wayward twangs we experience in the ear of our imagination as we look at it.

Only a musician could have made sound live in paint with such persuasive wit. Klee studied the violin and hesitated between careers of music and art. In his mid-twenties he was still playing in the Berne Municipal Orchestra. But in 1906, after his marriage to the pianist Lily Stumpf, he seemed to be content for his wife to be the professional musician of the family. Supported by Lily's earnings from teaching and concerts, he began to concentrate on painting in earnest.

Music intrigued Klee, however, throughout his artistic life, and returns again and again to haunt his work. The score – its staves and dots and ornaments – is part of his vocabulary of twiggy lines and punctuation. His description of the process of drawing as 'taking a line for a walk' has the same essence of melodic improvisation as musical composition. He spoke of this paintings with great simplicity: 'I had to do it like this so that the birds could sing,' he remarked in 1925.

In *The Twittering Machine*, a twitch of the handle has brought these miniature soloists into action on their high wire above a hint of a stage (furnished with the ghost of a music-stand) against an acid rural harmony of colours. Could this be some tinny reminiscence of part of the *Pastoral* Symphony or an echo of the woodbird music from *Siegfried* (arranged by Kurt Weill)? A concertgoer would know these singing attitudes from the aviary of operatic nightingales (and cuckoos), and would be able to put a noise to the exclamation mark that emerges from the largest beak.

These bird-like minims in their cage of sound were painted in 1922 when Klee was forty-three. The last appearance of music in his work was in the final months of his life when, limited to bolder linear gestures by a paralysing disease, and knowing that death was near, he painted *Amateur Drummer* in 1940. This work emits quite a different sound. As directly as an archaic drawing on a cave wall and as cunningly as a cartoon film a few broad strokes from the hand of the dying artist sum up with a double thump the maladroit yet triumphant sound implied in the title.

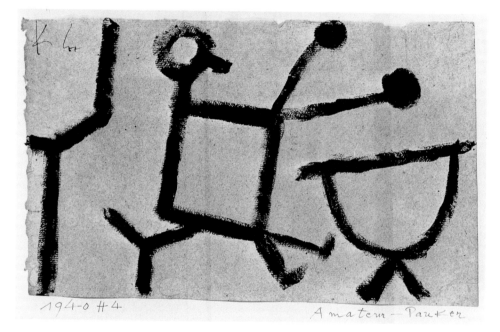

Paul Klee
(1879–1940)
Amateur Drummer
1940, coloured paste
on paper

Paul Klee
The Twittering Machine
1922, watercolour
Museum of Modern Art,
New York

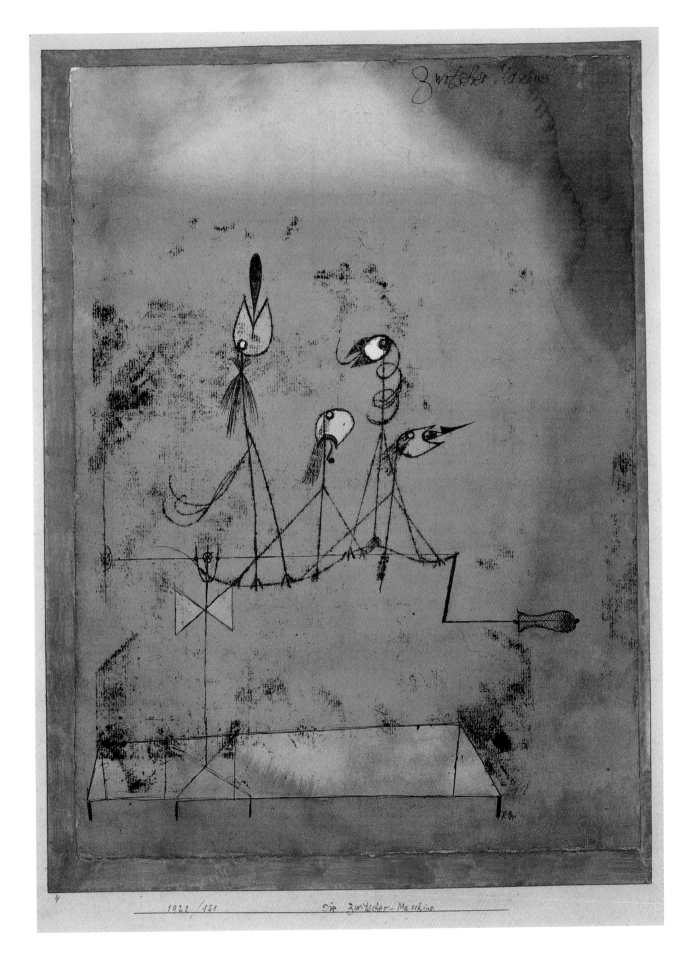

1922 /151 Die Zwitscher-Maschine

Music Invents a Patron Saint

Contract killers take note: trying to bump off a saint is a mug's game. They are far too tough, as those mobsters found out who thought of easy money as they boiled St Cecilia in a bath tub, only to see her step out fragrant and refreshed. So it was with the next dope, who had a swing at her with his sword, and not only failed to lop off her head but found himself with a broken arm as he watched her walk away with only a couple of scratches to show for it. True, she died of these, deciding to accept martyrdom and gather the roses of heaven with which she was often pictured.

So far, no music: it was only in fact as the result of a happy textual accident that Cecilia became its patron saint. Early representations show her without musical attributes and at least one of them even gives us her smiling as the angry bath-water bubbles away. More than a thousand years after her death a mistake in a Latin antiphon makes her sing to God not 'in her heart' merely, as the original words proclaim, but (by implication) to her own organ accompaniment. Thus she filled a vacancy long left open by departing pagan Muses for the emblematic figure of music.

Raphael's painting is therefore an early vision of her in this role. At first glance it seems a celebration of music as a holy art, since Raphael is incapable of bearing negative messages. The picture, however, has a heavy political point it is condemned to make. Pope Leo X disapproved of instrumental music in church and Cecilia here is ironically shown as having cast away most of music's resources. Her own emblem, the portative organ, is the last to go, held as if in disgrace, with its pipes dropping out, before itself being thrown down to join the broken instruments at her feet. Meanwhile, up above, angels demonstrate Liturgical Correctness in unaccompanied song. Musicians in their ever tenuous profession must have looked at this official image in despair as each damaged instrument signalled unemployment for one of their number.

That Raphael, himself a lover of music, agreed with this view is doubtful, but he who sacked the pipers called the tune. The almost voluptuous harmonies of the painting and the rhythmic composition built around a syncopated X shape centring on Cecilia's right hand and running from one side of the image to the other) somehow deny the subject-matter, with their augmentations of richness and complexity. They contrive to make resignation rather than pious renunciation the overall mood.

This masterpiece sings out from the walls of the Pinacoteca in the city of Bologna where, sixty years after Raphael's tragically premature death, Domenichino was born. His St Cecilia has forgotten the strictures of that already distant Pope. We are now in a period when church music approaches its ultimate lavishness. Indeed, the saint is seen playing the seven-stringed viola bastarda with its Monteverdian associations. The little angel (whose silhouette plays such an elegant close harmony duo with the outlines of the instrument) holds up the score, but the true prompting of inspiration is from above.

St Cecilia was newly topical in Domenichino's youth. Her body was discovered in 1599 and reinterred with great pomp. Already, some years before, she had been declared the patroness of music and all musical academies. It is no surprise that the artist put all his skills into this image since he himself was an ardent musician and music theorist. He was obsessively dedicated to discovering the scales of the ancient world, forever retuning instruments to his changing ideas of a mystical Natural Reason that inhabited both tonal proportions and the symmetries of nature. Domenichino was successful and popular in his lifetime and inspired jealousy in his fellow painters: it even seems probable he was poisoned by some Salieri-like artistic rival.

That a musical instrument should provide the centre of a holy trinity is a witty blasphemy that demonstrates not only how far doctrine had travelled in the hundred years that separate the two pictures but how much prestige the art of music had gained. Enough perhaps to be independent forever of killjoy Popes.

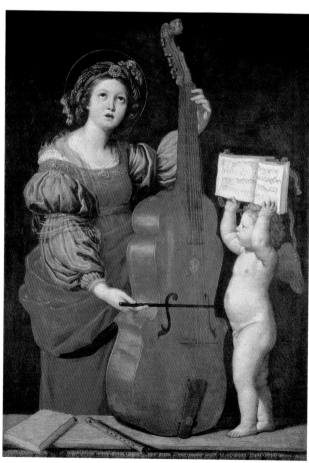

Domenichino
(1581–1641)
St Cecilia
c.1620, oil on canvas
Louvre, Paris

Raphael
(1483–1520)
*St Cecilia with
Attendant Saints*
1513–16
oil on panel
Pinacoteca,
Bologna

Model Sisters of the Piano

There are few more touching visions of sisterly warmth than the paintings Renoir made in the 1890s inspired by Yvonne and Christine Lerolle. The series starts with what the cinema would call a long-shot of a room in which such a scene at the piano is an incident: the artist then zooms in on the action of the girls themselves, of which he paints five versions, partly to explore the possibility of the subject and partly because he knows he has a winning image on his hands. This group, of which the Paris version reproduced here is one of the finest, leads, via one or two studies, to a close-up portrait of the sisters done from life.

Lerolle himself was a fellow painter and, like Renoir, a passionate music-lover; the house formed a salon where progressive musicians and artists met. His wife was the sister of Chausson who together with Renoir, Degas and Debussy was a frequent visitor. Renoir worshipped musicians, especially (like so many of the Post-Impressionists [cf. p. 60, 61]) Wagner, whom ten years before in 1882 he tracked down in Palermo where the composer was finishing *Parsifal*: he squeezed thirty-five minutes out of the master which resulted in a sketchy portrait.

That Renoir was by 1892 at last becoming a recognised artist can be deduced from the purchase of this picture by the French State (albeit after much persuasion by Mallarmé, another member of the Lerolle circle).

Though capturing an artless moment of youthful innocence, the painting is crafted with professional guile. Such romantic visions can only be kept this side of sentimentality if they have a solid architecture. Here, three kinds of structure are at work. The first is pure geometry, with the canvas divided from each of its corners by a huge cross of diagonals strengthened by a decisive vertical formed by the yellow edge of the curtain and passing down through the player's hands and the end of the keyboard. The other two structures are mirror-like in that the real embracing gesture in space of the girl in crimson is echoed on the picture surface by a metaphorical encircling of pinks, reds and browns.

Debussy's music, which often initially seems formless and vague (and indeed, much to his annoyance, came to be referred to as 'impressionistic') nevertheless proves to have been built around strict formal skeletons. Similarly, here Renoir's painting is infinitely explorable in its repeating diagonals and in elements like the contrary motion of the curtain's curve, with its reflection in the arc made by the arm of the girl turning the page which continues up to her sister's hand (a shape that is repeated in the right-hand corner of the work by an apparently casual sheet of music and part of a leather chair).

By the time of the commissioned portrait, five years have passed. While the earlier paintings were done with the help of paid models, the sisters are now posing themselves. They are similarly dressed and the embracing pose is recapitulated. Yvonne Lerolle has become an outstanding pianist to whom Debussy (who did not throw such favours around) had dedicated his first *Images* pieces (*Images oubliées*, 1894). The scaffolding of the work is now more severe, based on an upright central cross generated by the two picture frames. The picture is saved from rigidity by a soft pinkish piece of cloth in the bottom right-hand corner which itself sets up a sequence of steep diagonals.

It is difficult, now that Impressionism is synonymous with pictorial reassurance, to see its original radical insolence: the general idea of modernity has departed from the painting. Its unequivocal harmonies of colour were once violent and modernism was everywhere announced. Even the paintings on the wall, both identifiably by Degas, were scarcely more than ten years old and Yvonne Lerolle is likely to be playing an advanced work by a living contemporary. In today's terms it is as if we were looking at a picture in which she were playing Stockhausen with pictures by Baselitz on the wall behind her, the whole seen through the eyes of Lucian Freud.

The constant element between these two pictures is nonetheless the source of Renoir's initial inspiration, a loving bond between sisters, a mutuality of spirit that had its expression in music and its realisation in art.

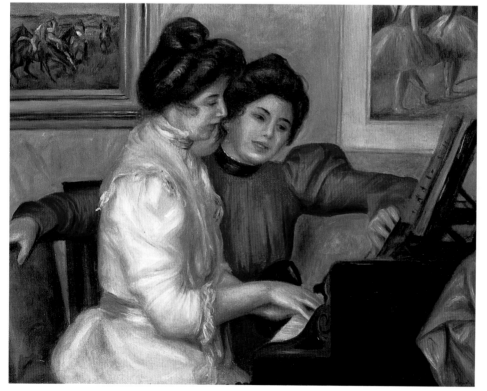

Pierre Auguste Renoir (1841–1919), *Yvonne and Christine Lerolle at the Piano*, 1897, oil on canvas. Musée de l'Orangerie, Paris

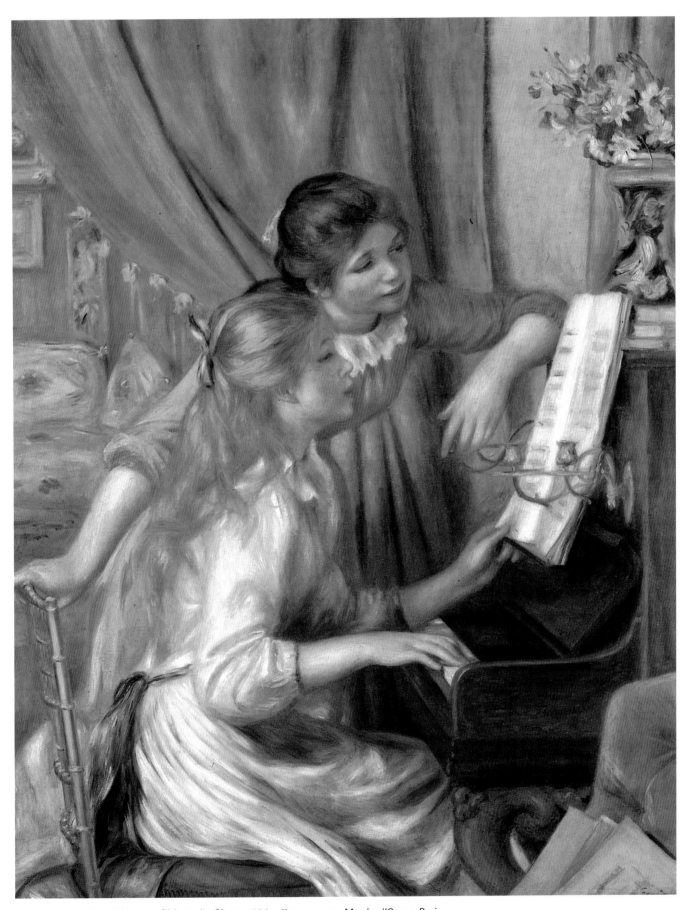

Pierre Auguste Renoir, *Young Girls at the Piano*, 1892, oil on canvas. Musée d'Orsay, Paris

The Body of the Instrument

The closest of all embraces between music and the visual arts occurs when the sound-making object itself becomes sculpture. The modern violin is one of the most aesthetically pleasing shapes to have evolved and the anatomical naming of its parts (belly, shoulders, neck) still echoes its nearness to the forms of prehistoric Mother Goddesses in the Cyclades. From Ancient Egypt to the present day the ornamentation of instruments has evoked the human and animal world, and it is still common to see a violin scroll carved as a head or a gilded harp rest on a clawed foot.

In Africa these transformations are the rule rather than the decorative exception. All over the continent drums become animals, bells have faces and gongs do duty as spirit figures, while horns assert their chryselephantine origins. The instrument must lead a double life in many

African societies, both embodying an element of magic as well as bodying it forth in sound; losing none of its musical practicality while attaining the stature of a unified work of art.

From the Fante, an Akan group in Ghana whose many militia houses need drums among their competitive paraphernalia, comes this instrument that tells its own sturdy story and is ripe with latent sound. The female torso is often evoked as a container in pottery; here the analogy is pushed to poetic limits in a container of resonance, air linked via the firmly planted legs to the earth via the animal. The head of the drummer completes the figure only when it is played. Wit and symbol act together with sculptural mass to make a believable Mother Drum for a proud society.

It is in the heart of Africa, however, in present-day Zaire, that this duality is most perfectly resolved, among the Mangbetu (perhaps the most aesthetically inclined of all groups, as refined in their hairstyles as in their architecture) and their near neighbours the Azande. These form a kind of cultural common-market feeding off each other's inventions. For all the delicacy of Mangbetu carving it is the more robust Azande who have brought nature, music and art most brilliantly together in their fashioning of instruments.

The humblest of all music-making devices is the *mbira*, sometimes called the *sansa* and most often referred to by colonialists as the 'thumb piano' (in what is after all a fair description of its playing method). This is found throughout Africa in a host of shapes and forms. It can be made by a child as a simple board with a series of flattened nails tied over a bridge, or by a master carver as a complex construction incorporating a gourd as resonator and shells or (as in many recent examples) bottle tops which rattle in time to the striking of the keys. They are played to accompany songs and dances or as virtuoso melody and rhythm instruments in their own right.

This most spectacular of *mbiras*, made by a great Azande artist at the end of the nineteenth century, defies the musician to produce anything but the most elegant and invigorating sounds. It is of a type specially commissioned by a man whose wife had given birth to healthy twins and its first task, both sculpturally and musically, was to celebrate the event. Its joyful anthropomorphism challenges the player to equal the grace and elation of the dancer he holds. That this music in praise of the fruits of a woman's body will itself be given life within, and emerge from, a beautiful female form is the happiest of inspirations, all the more so since among the Azande both sculptor and musician would invariably be male.

Regrettably silent since it was brought back by an ethnographic mission at the beginning of the century this *mbira*, eloquent even in its silence, now stands in the Tervuren Museum, a tramride away from the centre of Brussels. One can only guess at the sweet and intricate music its gentle bamboo keys once made.

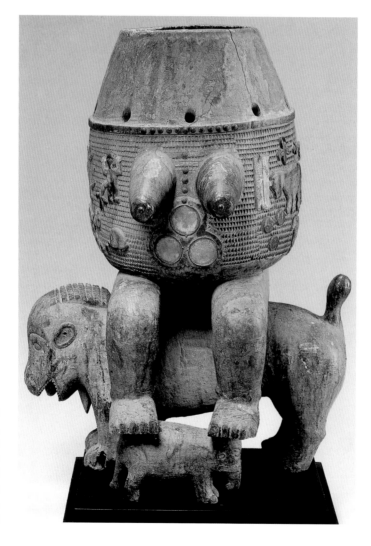

Unknown
Fante artist,
Ghana
Drum
c.1940, wood
Private
collection,
Paris

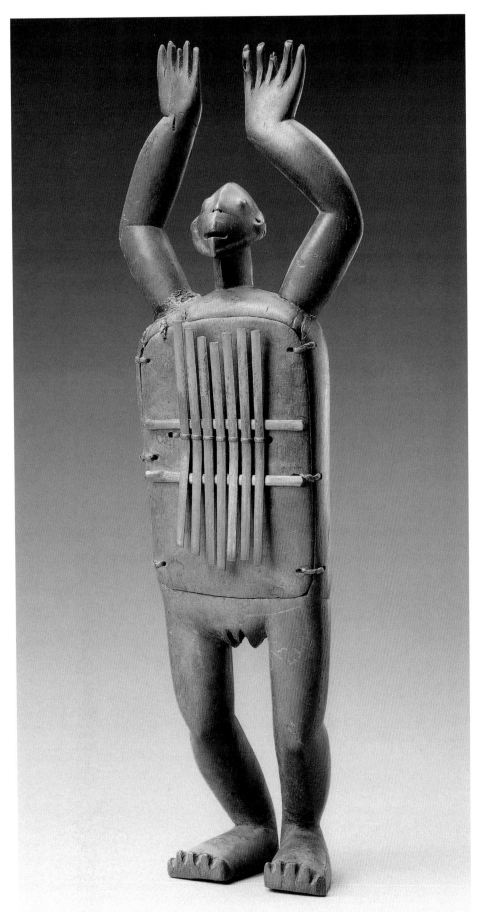

Unknown
Azande artist,
Zaire
Mbira
(thumb piano)
c. 1890, wood
with bamboo keys
and attachments
Royal Museum
of Central Africa,
Tervuren, Belgium

Schubert with Variations

Poor old Schubert. If only he were to pass this way we could dash out into the street and tell him the good news of how it all came right in the end: how the list of books about him itself now fills a book, and how his music is played on gramophones of all vintages by generations of *Desert Island Discs'* more discerning castaways. We could reassure him that his works gradually emerged from the drawers of oblivion and recount how Grove (of Grove's Dictionary) and Sullivan (of Gilbert and Sullivan), for example, made a pilgrimage to Vienna and found the full score of *Rosamunde* exactly where he had last put it with his own hands.

Pictorially, with one exception, the news would not be so good. The pictures of his own time, notably those by his gifted artist friend Moritz von Schwind, gave a one-sided view of him that backfired as a public relations exercise in that he seems to be cast in a limited role. Time and again Schubert features as the Pickwickian protagonist of convivial moments. He and his band of companions are forever picnicking, or going off for a ride in the Vienna woods, or playing charades or enjoying, with wine in plentiful supply, the marathon musical evenings known as Schubertiads. He is a local figure, as restricted to Vienna as Satie was to Paris.

His later fame served to fill out this image with added romance, creating the simplified and adorable stereotype of the nineteenth-century imagination. This is a Schubert taken over in the twentieth century by the cinema. Titles of the films based (ever more loosely) on the composer's life tell their own story. The invention of full sound more or less coincided with the centenary of Schubert's death and *Love Time* in the early Thirties was swiftly followed by *Blossom Time* of 1934 (a Richard Tauber vehicle known in the US as *April Romance*). In 1941 *New Wine* appeared, in which Schubert attempts to enlist Beethoven as his patron and gives up his girlfriend for a life in music. This in turn was followed by *Symphony of Love* in 1954.

The beginning of this imagery can be seen in Julius Schmid's bravura salon composition painted one hundred years ago. Such pictures, with their attention to the finer points of dress, texture of materials and verisimilitude of multitudinous props, are the Merchant Ivory costume dramas of their time. They are full of anecdotal detail and cover layers of artifice with a general appearance of naturalism. The inventory of characters and their variety of attitudes and expressions is the result of casting and acting: there is no mystery and the artist is caught cheating in ways more appropriate to the stage. Everyone knows that moment in the theatre when candles are lit and the lighting goes up in disproportionate degrees. This is the trick played by Schmid: even such a generous array of candles would produce darker crevasses of shadow and brilliant planes of brightness. All has been evened out with a sourceless infill of illumination. Schubert himself (as if to prepare him for his cinematic career) has had an extensive chin job and a more glamorously bouffant coiffure. Schmalz starts here.

Within two years of Schmid's painted fiction, Gustav Klimt made (also in the composer's home town) an icon of Schubert that could not be further from this type of stagey extravaganza. Now love replaces sentiment, sincerity drives out trickery and all the work's poise and intensity, its passages of troubled chiaroscuro and areas of serenity act as a true correlative of Schubert's complex and ambiguous musical personality.

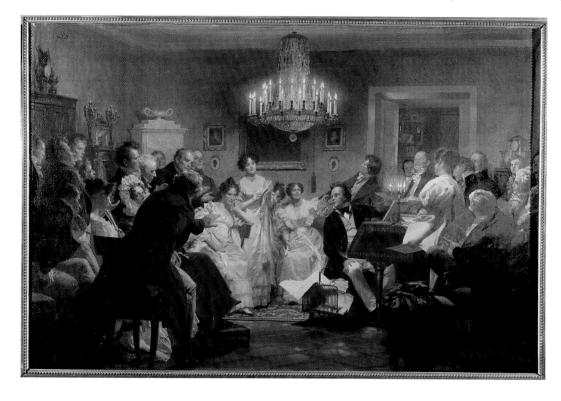

Julius Schmid
(1854–1935)
*A Schubert Evening
in a Vienna Town House*
1897, oil on canvas
Historical Museum
of the City of Vienna

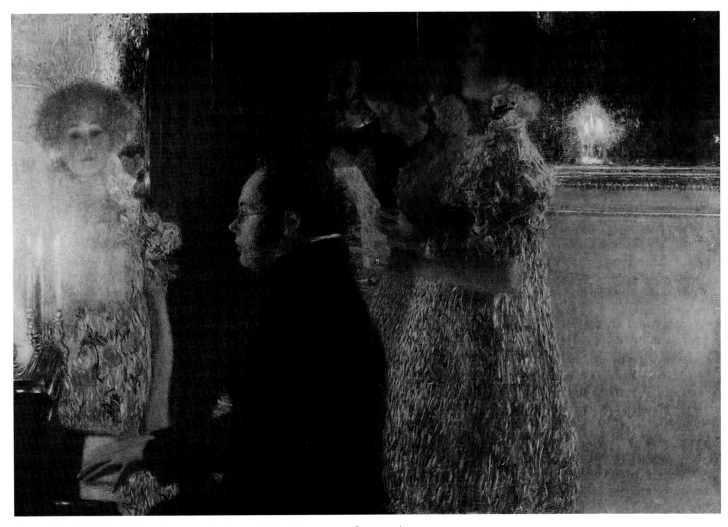

Gustav Klimt (1862–1918), *Schubert at the Piano*, 1899, oil on canvas. Destroyed

Here it is the painting itself that is doing the enactment rather than its modest cast of five, four of whom are seen either full face or in profile with the minimum of expression. Schmid's 'tableau' is crowded with 'expressive' things for want of the genius that makes colour and composition expressive in themselves.

Out of the magic silence that Klimt creates we can imagine wonderful sounds emerging, such as the evocative opening chords of Schubert's quiet hymn to his own art, the song *An die Musik*. The composer is once again surrounded by women but these are as other-worldly as vestal virgins serving the muse. They are dressed with outrageous and refreshing inauthenticity

in shimmering fabrics which act as an analogue to vibrations of sound. The composer's face, however, is reverently copied: Klimt does not want to dodge the challenge of making us believe that these unspecial features could transcend their plainness in the trance of art. Far from avoiding problems, the artist takes advantage of them. Here candlelight *is* candlelight breaking the darkness to make blocks of alternating brightness and shadow that, progressing from left to right across the canvas, echo the contrasting sections of a song which fades in a quiet coda. The full register of tonality is present from the most sonorous blacks to the highest pitches of golden white.

These two pictures dramatise that chasm of culture which separates illustration from the inventions of true art. Now that we have begun to know a more subtle and complete version of Schubert (both as human being and creator) Klimt's painting becomes richer and its sombre intervals more real. Schubert deserved at least one great painting to celebrate him and this magisterial yet tender homage of one Viennese to another is it. Or rather I should say *was* it, for it seems almost a collusion with the ironies of Schubert's existence that Klimt's masterpiece was destroyed by fire in the Second World War.

A Muse Between Muses

Here is a tug of love between Music and Painting over their mutual protégée, the young Angelica Kauffmann. The parental Muses struggle for custody in high Romantic vein: yet something is wrong. The clue is in the date of the picture. In 1791 the youthful maiden in the middle is fifty years old. Already she is the toast of cultural Europe, a founder member of the Royal Academy of Arts in London. She has inspired the love of Joshua Reynolds and of the eager Goethe, who could not tear himself away from her prototypical bohemian salon in Rome.

Thus it is already game, set and match to Painting and one must look elsewhere for the meaning of a work which scholarship has tended to take at face value. Certainly it is not a mere narcissistic exercise in self-dramatisation, but rather a study in dialectics from her own experience. It is a game of opposites including that old polarity between the active and contemplative life that still haunts religious debate.

This piece of retrospective emotional theatre also proposes what now might be called a feminist agenda, but I think Angelica Kauffmann had a more universal theme in mind. The key to the matter is the inequality of the contest and the dilemma is first declared in her earliest surviving work, done at the age of thirteen when she really was on the threshold of the drama re-enacted in the later picture. The daughter of a competent painter, she was a *Wunderkind* of almost Mozartian precocity and her musical gifts were apparent in early childhood. The purity of her voice and her musical intuition, both vocally and at the keyboard, raised hopes in her parents of a dazzling and socially acceptable career; yet the technical level of this stiff rococo self-portrait is already assured enough to announce another and more creative possibility, that of making art herself rather than merely interpreting the labour of others. The dutifully copied-out canzonetta in oil-paint is emblematic of the choice.

In today's world the interpretative artist is the darling of the media. Pavarotti's thimbleful (albeit a golden thimble) of talent will project him onto the cover of a music magazine, whereas the protean artistry of Harrison Birtwistle will not. With financial rewards it is the same: either would faint on finding themselves suddenly with the other's bank account. But there are compensations as, in this picture, the beckoning figure of Painting suggests.

The decisiveness of the composition makes me suspect that Angelica Kauffmann wants to say that very early on the risks of creativity were more alluring than the relative safety of performance. She makes Music a dull and submissive figure of whom she is taking leave. Our Western reading habits make our eyes look at paintings from left to right: the past is usually on the left and we approach the energetic centre to the right, here guided by a ribbon of arms and hands punctuated by a score and a palette. The score represents what has been done and the blank palette the unknown, the to-be-done. The pillars and curtains give a domesticity to Music which contrasts with the challenging landscape of escape and adventure proffered by Painting. If our

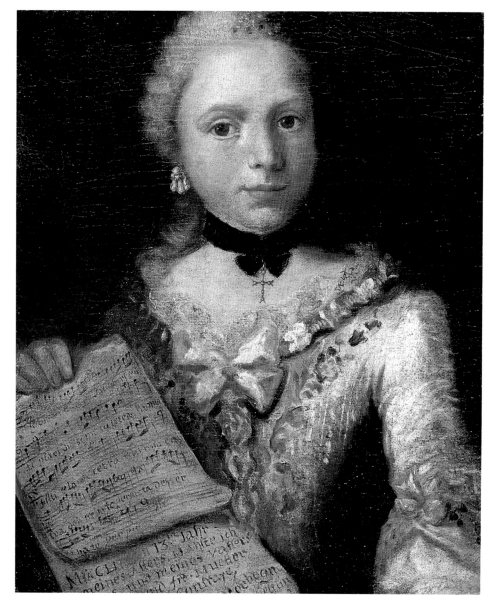

Angelica Kauffmann
(1740–1807)
Self-portrait at Age 13
1754, oil on canvas
Tiroler Landesmuseum
Ferdinandeum, Innsbruck

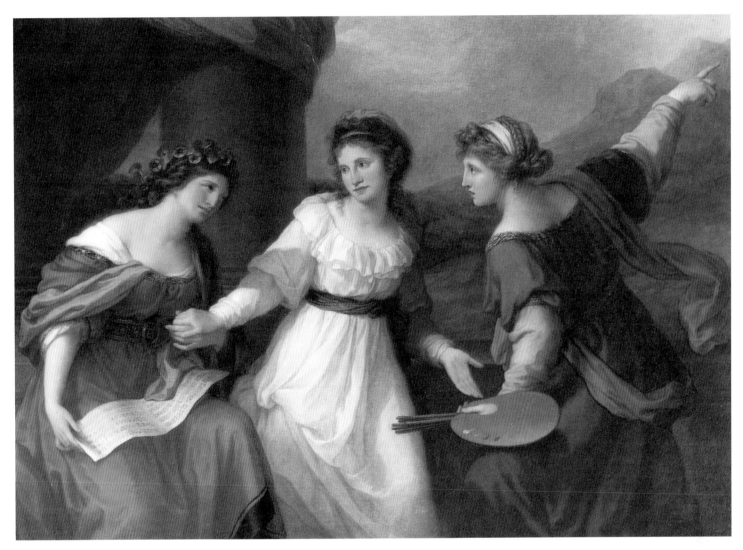

gaze tries to stray backwards, a cunning compositional loop ensnares the eye and drives it towards the right again in the unequivocal direction that the heroine's bodily movements make inevitable.

The grace of the painting is that there is no hint that she would yield an inch of femininity in pursuit of her fulfilment. Angelica Kauffmann was a beautiful woman in her own imagination as well as in actuality. It was her wit as much as her vanity that gave rise to her most audacious self-portrait some years further into her fifties. Asked to produce a new likeness

of herself, she made a glamorous copy of the portrait that Reynolds had painted of her thirty years before, with not a wrinkle added nor a touch of grey on her auburn curls.

It was only in fact when the choice was vindicated and the battle won that she could paint the picture above. The Muse of Painting gestures towards a high temple on a Parnassian mountain top, a Temple of Fame that she might strive to reach. Shrewd artist that she was, she painted the goal of her quest only when she was sure she had achieved it.

Angelica Kauffmann
Self-portrait: Hesitating Between the Arts of Music and Painting
1791, oil on canvas
Nostell Priory,
Wakefield, Yorkshire

How to Paint a Symphony

Artists have always been rather jealous of music. It possesses order, mathematical elegance, metaphysical scope and emotional identity without being tied to the business of description or imitation. A piece of music, like a crystal or a tulip, is an autonomous object and not a copy of another thing in the world.

Although abstraction had existed for millennia in other cultures (and even in the Western tradition had been fearlessly humming its tunes in the decorative arts) the first great painter to do anything about the situation was the Russian-born Wassily Kandinsky. Between 1908 and 1912, he managed, using music as a key, to unlock the door to this new freedom. He never passed back through that door ('objects are my enemies', he used to say) and moreover, never threw away the key, nervously reassuring himself (as one might in purse or pocket) of its presence in the titling of his paintings. Almost all the early abstracts had names that hold on to musical forms and procedures, such as concerto, symphony, fugue, etc. Here the words 'improvisation/study' are meant to conjure up an impromptu composition. The irony is that Kandinsky, now free of representation, has not quite leapt into the void without a parachute: music sustains him and thus he still ends up representing *something*. His writings show that he did this in quite a literal way, making parallels between sounds and colours (black and white are different kinds of silence, passive and active, and a certain yellow has the quality of a contralto voice, and so on, in an intuitive vein). He even carries the analogy into the physical process of painting, equating the pressure of the brush, broadening the line as it increases, with that of a bow on the strings enlarging the sound.

All of this he communicated to Schoenberg, to whom he first wrote out of the blue after admiring a concert in Munich. Schoenberg, who had staged an equivalent escape from traditional tonality, was as enthusiastic a painter as Kandinsky (a proficient pianist and cellist) was a musician (cf. pp. 64/65). Their long correspondence is one of the treasures of the century's artistic archive. It is a revealing paradox that Schoenberg, whose music had helped liberate Kandinsky from the restraints of reference, was, in his almost professional career as a painter, hardly tempted by the idea of abstraction.

As soon as we realise that a largely musical impulse lies behind this particular canvas, it changes from a seemingly chaotic parade of visual excitements to a readable sequence of quasi notations. As one travels from left to right over a ground bass of brown, large blocks of sound-events are punctuated by white silences joined by the menace of jagged black interruptions towards the emphatic end. Whatever world of tones the picture inhabits, an almost neurotically busy piece is conjured up.

The clarity and diversity of these stacks of sound remind one less perhaps of Schoenberg than of Webern, whose contraction of musical duration makes the hearing of his work akin to the experience of absorbing a painting.

A distinctly Edwardian air, however, hangs over the little linocut of Kandinsky at the harmonium, which gives us not only a glimpse of the artist as music-maker but of the period itself. Gabriele Münter was a gifted artist who lived with Kandinsky through those crucial years of experiment. Her other pictures of her lover suggest a bicycling, hiking and farmhouse-tea side of the world that could as easily belong to Elgar and his friends. We peer through a pictorial window at an almost *fin de siècle* scene, yet, were the window to be thrown open, we would no doubt hear the challenging sounds of the twentieth century. It is easy to forget that the wild pioneering masterpieces of modernism were often first viewed under oil-lamp and gaslight by men in stiff collars who arrived in fiacres and hansom cabs.

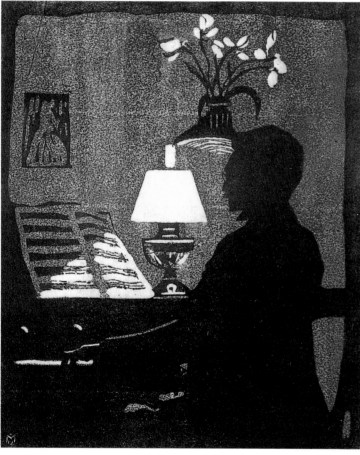

Gabriele Münter
(1877–1962)
Kandinsky at the Harmonium
1907, colour linocut
Lenbachhaus Gallery, Munich

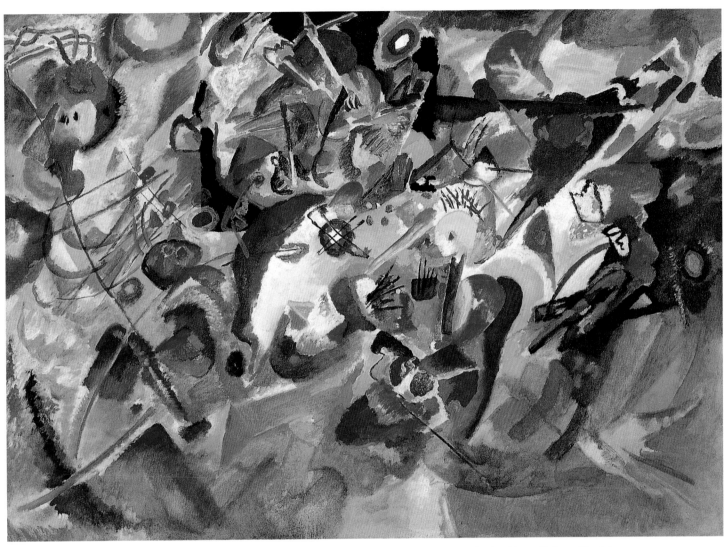

Wassily Kandinsky (1866–1944), *Study for Composition VII (Improvisation 3)*, 1913, oil on canvas. Lenbachhaus Gallery, Munich

The Talented Linleys

Gainsborough was mad about music and an unashamedly emotional listener. His house was full of instruments he had half learned to play in a succession of enthusiasms, starting with a violin accepted in part payment for a youthful portrait.

During his years in Bath the treadmill of portraiture trundled on. He had to paint likeness after likeness, though his first love was landscape. Ironically we are grateful to those society people who lined up to be made elegant forever by the greatest portraitist in English history. He himself came to resent the servitude of what he called 'the face business'.

Working for the Linley family was somehow different. The constant music-making at home and the concerts organised by the father, Thomas Linley (the kind attended by the young Jane Austen),

created a family atmosphere from which the sounds of playing and singing were rarely absent. The children of the house were part of a musical dynasty whose quality can be judged from their six individual entries in the *New Grove Dictionary of Music*.

Both Elizabeth Ann and Mary Linley were professional sopranos. They featured regularly in the oratorios of the day. Elizabeth Ann was considered not only one of the finest living singers, but an epitome of beauty. She had many admirers and extravagant suitors; yet it was the raffish author Richard Brinsley Sheridan who eloped with her in her eighteenth year, in a fashion worthy of his own plays. As the happy Mrs Sheridan (all was soon forgiven in the good-hearted world of the Linleys) her musical life became more private yet no less active, especially in the many

domestic concerts given in association with that other distinguished family, the Burneys. In the picture of the two sisters it is Mary who holds the music, appropriately since it is a piece with words by her husband Richard Tickell (also an author) and set by her father.

The portrait has its own special mood of comfort, confidence and quietude. Like Renoir's pictures of the Lerolle sisters (cf. p. 30) it could have been painted only by an intimate of their intimacy. It is in Gainsborough's most brilliant manner. His love of light and landscape surrounds his sitters with vibrant air that is palpably fresh, with no hint of that studio twilight that often stifles the subjects of contemporaries such as Sir Joshua Reynolds. The artist worked quickly, painting with long brushes to avoid finickiness. What seems from a distance to be an immaculately detailed costume turns out, when approached, to be a shorthand haze of flickering brush strokes. One senses in the informal dress, in the frank gaze of Mary and the affection of her sister, the relaxed relationship between the painter and his favourite family.

The painting hangs in the lovely Dulwich Picture Gallery with other of the artist's portraits of the Linleys, including that of their most tragic figure, Thomas Linley Jr, who was an infant prodigy on the violin and a precocious composer. Born in the same year as Mozart he met his great contemporary in Florence at the age of thirteen. Mozart (who was of all people most unlikely to have been impressed by boy wonders) said later of him that had he lived he would have become 'one of the greatest ornaments of the musical world'.

Unlike the full-scale pastoral image of his sisters, this portrait is in Gainsborough's simplest style. Achieved in two or three sittings this was no doubt a gift from a friend of the family rather than a commission. A silly boating accident abruptly ended the life and career of the young musician in 1778 at the age of twenty-two: the fulfilment of his promise would have given the Linley family an international rather than merely local celebrity. Luckily they received a compensatory immortality through the graceful works of the artist they befriended and whose musical life they so amply enriched.

Thomas Gainsborough (1727-1788), *Thomas Linley the Younger*, c.1773, oil on canvas. Dulwich Picture Gallery, London

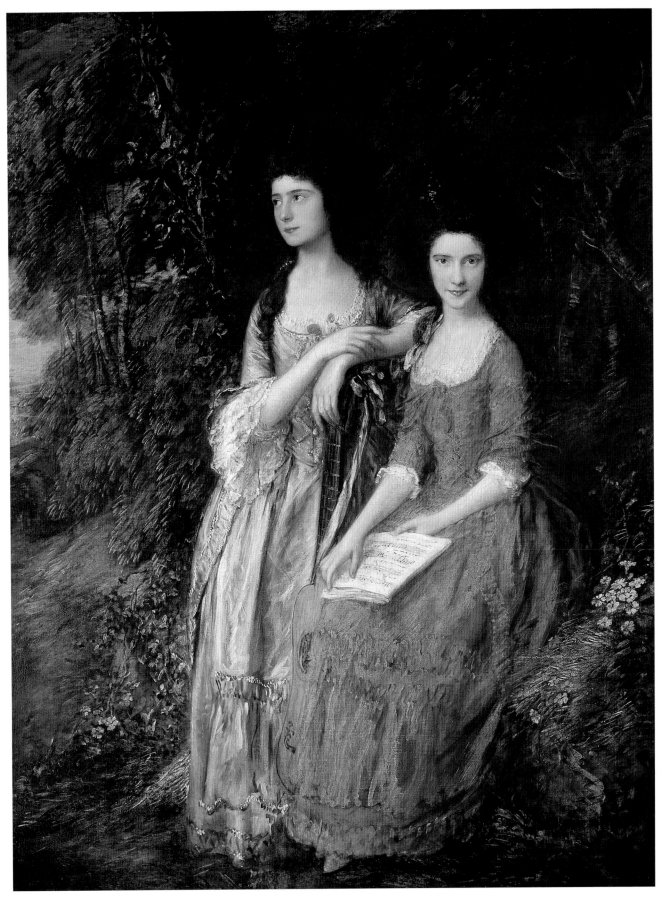

Thomas Gainsborough, *The Linley Sisters*, c. 1772, oil on canvas. Dulwich Picture Gallery, London

Buried Sounds of China

The ancient Chinese believed that you *could* take it with you. Like their contemporaries the Egyptian pharaohs the aristocrats of China were buried with the necessities and luxuries that served their earthly days, so that their life beyond the grave would know no diminution. Music is often thought of by present bureaucracies as an extra, a mere ornament to existence, yet both the tombs of dynastic Egypt and the burial palaces of the Chinese lords show its recognition as one of the human priorities.

Not only would you need a terracotta army to defend you in time of war, but you would also require an ample orchestra to enrich your soul and divert your mind in time of peace. Without the services of such ghostly musicians the elegant dancers of coloured clay could not dance, stories could not be told by the sculpted bards, and neither ancestors nor spirits could be contacted.

The most spectacular confirmation of these beliefs can be seen among the recently excavated treasures shown in the British Museum's 'Mysteries of Ancient China' exhibition. When the two-and-a-half-thousand-year-old tomb of Marquis Yi of Zeng State was opened in 1978, the central room was found to be largely devoted to a massive set of sixty-five tuned bells still mounted on their richly lacquered stands.

Three years later, in a neighbouring tomb, archaeologists discovered, similarly mounted and again dominating a central chamber, the set of thirty-six ornate bells shown here. Although their makers already had more than eight centuries of experience to draw on, it is hard to overestimate the prodigious feat of bronze-casting that they represent. Each bell is doubly tuned, so that its elliptical cross-section allows a different note to be sounded by striking either the side or the centre of the rim. That this precision could be achieved while making an object of formal beauty embellished with the most intricate of ornamentation is a balancing act between musical imperatives, artistic brilliance and metalworking virtuosity.

The structure of what is more an ensemble than an instrument implies a

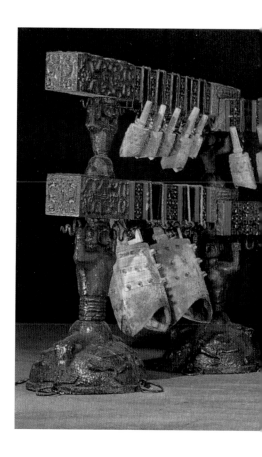

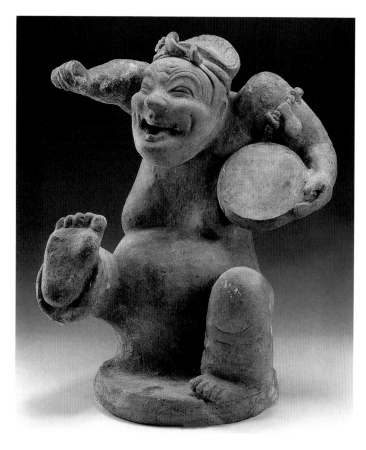

Drummer (Singing Storyteller)
China (Eastern Han, 25–280 AD)
Painted terracotta
Museum of Sichuan Province, China

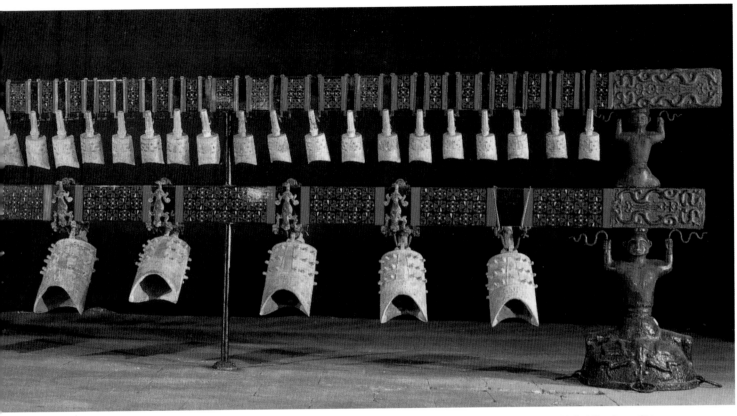

Bronze chimes with stand (reconstructed), China (Eastern Zhou, 5th century BC). Museum of the City of Suizhou, Hubei Province, China

number of players. We shall never know what concerted sound they produced yet, since the largest of the bells is a metre high, it was not a tinkling matter, but rather a complex of sonorous solemnity.

Indications, from the same excavations, of a less ceremonial music are found miniaturised in the oldest representation of a concert platform known, an open-sided pavilion in which a quartet of tiny instrumentalists (two zither players, a mouth organist and a drummer)

accompany two female singers. Their dress and stance seem more casual than courtly. Yet more informal still is the energetic drumming dwarf found in a tomb in the vicinity of the famous terracotta warriors. He is caught in mid-drumstroke, a foot raised to emphasise the coming beat with a thump on the ground. His face is creased in a wild grin as broad as that of a Greek mask of Comedy. The no doubt austere high Classicism of the bells of Marquis Yi is miles away and one is somehow

reassured to find that musical diversity two thousand years ago was as generous as it is today.

With the advent of recorded sound the bones of casketed Californians can now listen to their favourite hits or best-loved arias beneath the ground. An eternity of Elvis or an infinitude of 'Nessun dorma' (however ironic in the latter case) might be all very well, but the aristocrats of China fared better: even dead they had live music.

Portrait of a Heroine

Time is a strange concertina: events and encounters can squeeze or expand it. My son may well live to the year 2050 when the fact that he has shaken hands with someone who shook hands with Brahms will have become scarcely credible.

Art itself can also make time collapse and bring us into an almost physical confrontation with another human being, as in the case (thanks to Velasquez) of my melancholy friend Philip IV of Spain. Thus, turning a corner in the Robert-Schumann-Haus birthplace museum in Zwickau, Germany, one is suddenly ushered into the presence of Clara Schumann as she nears her sixtieth birthday.

Her romantic crisis with Brahms is long past and even further back in time lie the tragic madness and death of her husband. She is still active as one of the great concert pianists of the age, having made her debut fifty years before. Two of her children have died and she is now a grandmother. Indeed it is her grandchildren who have requested her portrait from the eminent Franz von Lenbach, the semi-official portraitist of the German élite. Clara Schumann's main activity as a composer is also in the past and a quarter of a century has gone by since she produced any substantial music of her own.

Although she now lives on into the era of instant photography it is this image of Lenbach's that persuasively captures her history and holds her life alive. Perhaps this is because the drawing itself inhabits more than one world, hovering as it does between Romantic lyricism and stern objectivity.

Such psychological penetration eludes the camera's frozen moment: only the artist is at leisure to record this or that emotion or mood as it passes through the sitter's face. Each part of what seems a single expression can be inhabited by a different state of mind and the good painter can make a virtue of the practical dilemma of drawing the eyes hours later than the lips. A master portraitist like Lenbach produces a unity out of such contradictions and we in turn can read the living face differently each time we see it.

Lenbach's method of work, as reported by Clara Schumann herself, was demanding on both parties. The clue to the conviction of the final result can be found in her account of 'a remarkable first sitting, just being on view ... he wanted to study my face before beginning'. It is a serious artist who spends a whole portrait session without making a single mark. However, once the artist got started with his watercolours and chalk on the tinted paper, he would work fast: in this case he finished the picture in a single day, at the end of which he had produced a remarkable image of the beauty of mature womanhood. Not only does one see Clara Schumann's high intelligence ennobled by courage in loss and richness of fulfilment, but one catches a glimpse of the wit and vivacity of the youthful Clara Wieck, who astonished the world and inspired both love and art in the brilliant young Robert Schumann.

Franz von Lenbach was seventeen years Clara's junior and on top form. His unfailingly perceptive portraits were engraved and anthologised, encompassing as they did most of the architects of Germany's cultural and political life throughout the second half of the nineteenth century, together with celebrities from abroad. He was himself an amateur musician and portrayed many other major musical figures including Johann Strauss, Hans von Bülow, Liszt and Grieg. One of his many images of Wagner is the subtly drawn head of a man at once deeply ruminative and highly ambitious.

Exceptionally among Wagner likenesses it catches both the visionary gleam of the heroic composer and that strain of selfish sensuality that marked his personal life.

But for the ultimate expression of a life in the world and in music I turn back to the frank and sensitive image of Clara Schumann as the masterpiece of this fine historian of faces.

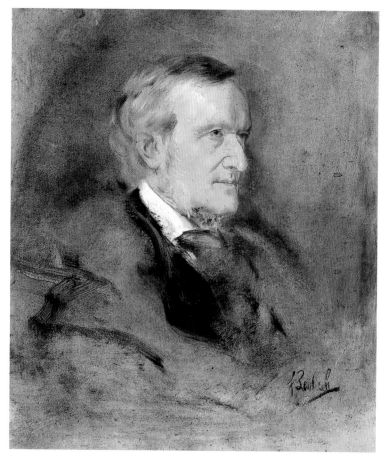

Franz von Lenbach (1836–1904), *Richard Wagner*, 1882–83, oil on cardboard. Lenbachhaus Gallery, Munich

Franz von Lenbach, *Clara Schumann*, 1878, pastel. Robert-Schumann-Haus, Zwickau, Germany

The Vanity in the Case

Holbein was never on better form than when he painted *The Ambassadors*. This mysterious double portrait, now brilliantly restored, hangs once again in the National Gallery, London, as a touchstone of Northern Renaissance portraiture.

Holbein had returned to England and its rich portrait pickings after an absence of four years and was eager to remind its court that no native painter could approach him in invention and skill. This commission came at an opportune moment and must have been the start of a lively collaborative enterprise between three young intellectuals with time on their hands. Jean de Dinteville, seen here in spectacular formal dress, was the ambassador from France. Remaining in England for Royal Wedding duty, he had been joined by his friend Georges de Selve, Bishop of Lavaur. The trio of sophisticated continentals would have discussed at length the programme of the picture: it self-evidently stands as an emblem of a new age of cultural confidence, where learning allied to breeding brought command of a changing world.

The panoply of scientific equipment is equalled in status by the attributes of music, a lute, a set of pipes and a hymnal. If an equivalent group of objects were to be arranged today it would no doubt feature the latest electronic gadgetry. Much of it would be imported, just as here the terrestrial globe predates English manufacture of such an item by more than half a century. The eternal verities of music might however still be represented by the lute's as yet unimproved upon technology.

Yet one notorious object in the picture brings everything into question. All its gear and finery are challenged by the ominous presence of an immense skull painted anamorphically (i.e., in a stretched-out fashion) at the bottom of the composition. Technically it is itself a unification of science and art and can only be normalised by either placing at its middle a specially made glass cylinder or by crouching down and looking up along its length. This latter is much easier to achieve in reproduction by a mere tilt of the page.

The juxtaposition of a skull with symbols of human enquiry and culture is a harsh reminder of the vanity of our lives and endeavours. The lute suddenly becomes a wooden shell of air capable only of a transitory delight. The instruments of measurement and speculation are brusquely transformed into epitomes of man's vain hope of achieving mastery over nature. The splendours of velvet and fur now merely clothe temporary bodies which in their turn clothe skeletons whose remains will become Shakespeare's 'bare ruin'd choirs where late the sweet birds sang'.

The metaphor of the painting is thus doubled. While it is still the depiction of man in his prime, possessed of the secrets of science and the spiritualities of art, it is now also what is called a *vanitas*.

A more typical example is Steenwyck's still-life: painted in Holland one hundred years later. Here we find again the conjunction of a skull and book, and pipes together with the inevitable lute. Other intimations of mortality may find their way into such *vanitas* pictures in the form of flowers (that must fade and die) or candles (that must gutter to extinction) or an hourglass with running sand (here modernised by Steenwyck into a pocket-watch): yet the essential recipe was the same. Music is invariably present as the art (at least before the age of recording) which passes away as it is made. Such paintings can be found in almost any of the world's art museums since they once adorned the homes of the prosperous, permitting them images of luxury with the alibi of piety.

As if he had not made his point with utter clarity, Holbein brings in yet another device (scarcely visible before the recent cleaning). Beneath the table and tunefully rhyming with the elegantly shod foot in front of it lies the black case of the lute, like the coffin of vanity closed on its emptiness.

With what grim delight Holbein and his colluding patrons must have hit upon that device and the idea of making the skull simultaneously huge and somehow barely visible. Everything in this virtuoso picture, including the manner of its painting, is what we would now refer to as state-of-the-art, and art in 1533, as can be seen, was in a very healthy state.

Harmen Steenwyck (1612–56), *Still Life: An Allegory of the Vanities of Human Life*, c.1640, oil on oak. National Gallery, London

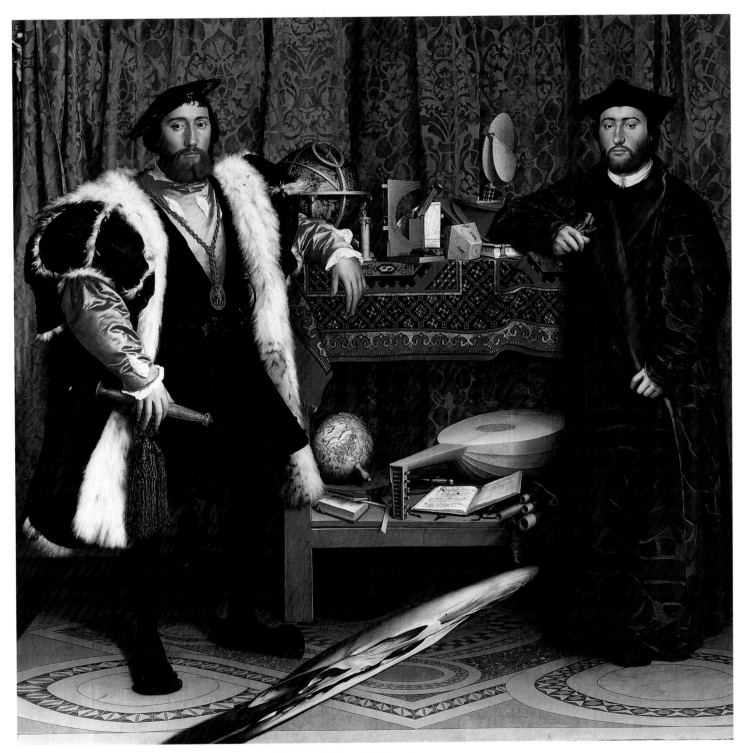

Hans Holbein (1497–1543), *The Ambassadors*, 1533, oil on oak. National Gallery, London

Eight Hands / Four Stands

In any television broadcast of piano or instrumental music we know that sooner or later the camera will make a lunge for the hands, whether it be the pianist's scurrying across the keyboard, inevitably mirrored in the gleaming instrument, or the harpist's catherine-wheel blur of arpeggios, or the conductor's noiseless gesturing. Except in the case of the singer (and even they are not exempt: witness Pavarotti's handkerchief routines) it is as if the hand generating the music were also expressing it.

At a piano recital the seats from which the performer's hands can be seen are the first sold. The audience on that side implicitly expects through their agency a greater communion with the music.

A final exaggeration comes where you would expect it, in the horror film. In *The Beast With Five Fingers* the eponymous villain is the severed hand of a dead pianist which now embodies all his genius and, in between a bit of strangling etc., brings off an amazing performance of the Bach *Chaconne* (arranged by the composer of the film's chilling score, Max Steiner) before clambering like a crab back into its box. Whether Ervin Nyiregyházi ever did anything else with his left hand (thoughtful of Peter Lorre to cut off the more effective limb), or both, I do not know but the playing stuck in my mind, perhaps because it *was* mediated through this steely team of fingers with no distraction from body or face.

Max Oppenheimer zooms in on the hands of the Klinger Quartet in a way no camera can, since the painter, free from the exigencies of actuality, may put their hands, and the instruments and scores which counterpoint them, wherever he likes. If in reality these painted players were suddenly set in motion, bows would clash, arms would tangle and scores, unsupported by music stands, would scatter on the floor. Luckily, the picture has its own self-contained movement cunningly achieved by causing the viewer's eye to travel in criss-cross fashion over the image's surface, bouncing back as if in a pinball machine whenever it meets the oval's edge. Thus the eye *performs* the picture, as if under the painter's instruction to do its looking *molto agitato*.

Whether the quartet was actually playing from blue-covered scores we shall never know, but their contrast with the warm-toned instruments, together with the combination of dark background against pale hands and pages, make a visual analogue of music's own oppositions of soft/loud and shorter or longer notes. Oppenheimer was a specialist in musical portraiture best known for his tortured Futurist picture of Busoni at the keyboard. Here he keeps himself to the look and format of a classical Cubist picture yet paints each element in a conventional way. What makes the canvas live is the intensity conveyed by the hands, which are sinewy and taut and doing real work. One white shirt-front is enough to signal the idea of a concert and an obtruding knee sufficient to suggest the presence of solid people: otherwise the references are reduced to the purely musical. The impacted composition kaleidoscopically suggests a difficult moment as eight hands grapple with something knotted like Beethoven's *Grosse Fuge*. Even to mention such a masterpiece is a tribute to the painting's success.

Art shares many of its figures of speech with literature: synecdoche, where the part stands for the whole (as the hands do for the Klinger Quartet), is taken to an even greater extreme in David Smith's painting of another named ensemble. He ignores all the elements in Oppenheimer's painting and takes its discarded music-stands to represent the members of the Budapest String Quartet. In a playful manner he shows in four variations on this prosaic piece of musical impedimenta the personalities of the players (one of whom is evidently short and tubby). On closer view, however, the picture, with its whimsical surrealism, is full of half-references to scores, notes, strings, etc. Smith, of course, in his pioneering metal sculpture, was a considerable artist, but here his *jeu d'esprit* makes a foil to Oppenheimer's *tour de force*.

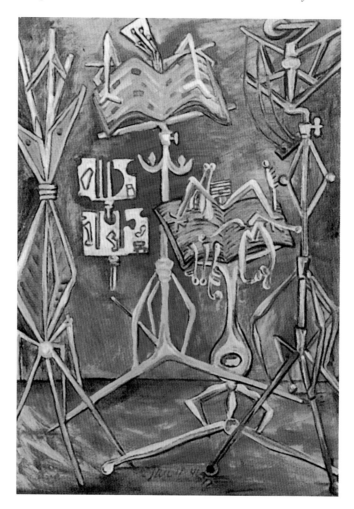

David Smith (1906–65)
Budapest String Quartet
1946, oil on paper
mounted on masonite
Smith Foundation

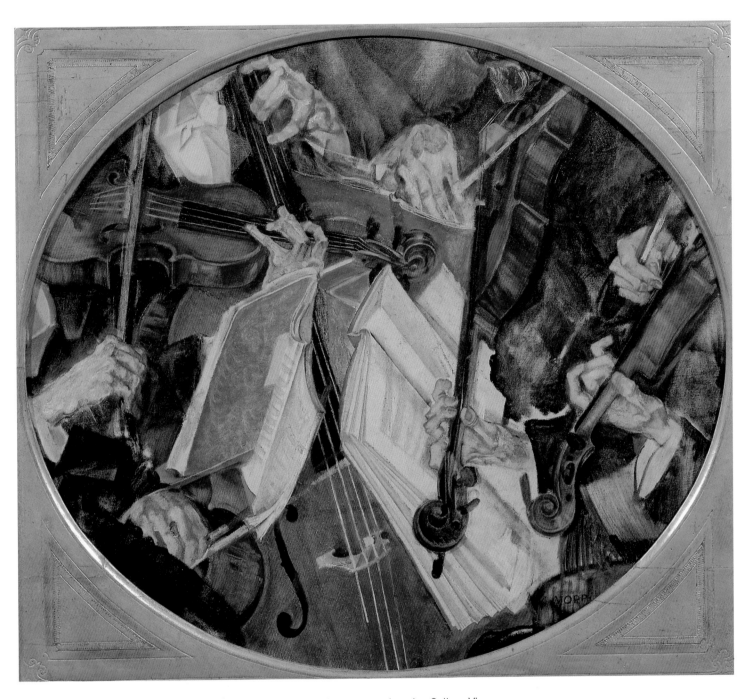

Max Oppenheimer (1885–1954), *The Klinger Quartet*, 1916, oil on canvas. Austrian Gallery, Vienna

A Marriage of Music and Art

Napoleon was no slouch at looting, as any visitor to the Louvre can see when they stand in front of Veronese's vast *Marriage at Cana*. Fatigue and the pain of 'museum feet' fall away as one is engulfed by its colour and energy or uplifted by its light and space.

There are moments too in the opera house when a collective gasp greets the spectacle revealed. The crimson curtains part to show a brighter, more coherent and more decorously populated world whose inhabitants move in a pattern as elegantly organised as the colours of their finery are sumptuously coordinated. The analogy is not fortuitous, for opera-goers will immediately recognise many of the tropes of grouping and architectural fantasy that have made this canvas the source of inspiration for generations of producers and designers. Two other coincidences help: firstly, that the vast canvas happens to be of the proportions of the proscenium stage and, at over thirty yards long, of the same scale as that of a major opera-house; and, secondly, that at the heart of this complex choreography is the presence of music itself.

Not only do the five musicians occupy the centre of the picture but they define its whole geometry. With Christ at the top of the gathering (the world of the spirit) and two thoroughbred dogs at the bottom (the idealisation of the animal world) the instrumentalists form a circle, a clear part of whose circumference is defined by the arm of the bass player. At the centre of the circle is a tiny hourglass. At the moment of Christ's first miracle (a transcendental party trick of turning more than one hundred gallons of water into wine) morality has become eternity. Music encircles the hour-glass to show that art too is victor over time and death. Even in a small reproduction one can see that this central circle is surrounded by larger concentric circles rippling out to the edge of the spectacle and unifying it both pictorially and allegorically.

The Church frowned on Veronese, viewing his frank secularisation of holy events as blasphemy. Luckily art is wiser than theologies (which it tends to outlive) and the young Veronese's life-affirming piety is generous, witty and majestic. The presence of the chamber group at a sacred occasion would not seem out of place in sixteenth-century Venice, where instrumental music often formed part of church solemnities. The players might indeed be performing part of a work by their contemporary, Andrea Gabrieli, the uncle of Giovanni.

Usually we do not know the names of the musicians portrayed in classical painting, but this is an exceptional case in which each member of the ensemble can be identified. In alphabetical order they are Benedetto Caliari, Paolo Caliari, Antonio Palladio, Jacopo Bassano da Ponte, Jacopo Robusti and Tiziano Vecelli. Palladio is the age's greatest architect (who had built the refectory for which this work was originally commissioned) and Bassano the leading member of a family of painters. They are in good company, as the more familiar versions of the other men's names in the line-up reveal. Robusti on the viol is better known as Tintoretto and Vecelli on the double bass is of course no less than Titian, while the Caliaris are Veronese himself (viola da braccia) and his brother. Thus painting and music are uniquely united and ennobled. High professionals in their own arts, these capable amateurs are also transformed into the group of groups at the gig of gigs.

Like the ageing Titian we may peer at the music on the table, yet we cannot properly identify it. We can, however, catch its harmonies by eye as they resonate through Veronese's ample scene and beyond.

Detail of Veronese's
Marriage at Cana

Paolo Veronese (1528–88), *Marriage at Cana*, 1563, oil on canvas. Louvre, Paris

A Search for the True Lyre

Magical things lurk in unpromising places. sometimes after long journeys in space and time. Under unforgiving light in a windowless room of a warehouse in the drabbest corner of London's East End stands an ungainly and anonymous crate. I had passed it many times in searching through the storeroom of the British Museum's ethnography department (making my earnest choice of exhibits for the Royal Academy's 'Africa: The Art of a Continent' show). One day I saw it being opened and experienced a shiver of rare excitement at what was revealed. A single word sprang involuntarily to mind and. through the customary barriers of British reticence. came (much to the curator's surprise) the shouted name. 'Orpheus!'

Sometimes we do not have the visual trappings in our experience to believe in the myths we love. Orpheus. the loving husband of Eurydice. who charmed hell itself with his music to bring his beloved wife back. had always in sculpture and paintings seemed musically under-equipped, as he is in the beautifully decorative Roman mosaic of the High Empire in which not only the creatures of the wild are tamed but Orpheus himself seems an urbane rather than a shamanistic presence.

The lyre as it comes to us in Classical art is often. for all its shapeliness. slightly effete. Poussin in his famous *A Dance to the Music of Time* gives the instrument its final refinement. Its curved arms only dimly remember that they were once the twisted horns of a wild antelope. and its immaculate circular soundbox has forgotten its beginnings as the shell of a giant tortoise against whose belly. covered in rough skin. the twisted gut once vibrated. All very well. however. to accompany the elegant ironic dance of neo-classicism. yet no match for the alluring Sirens whom Orpheus silenced with his song. nor potent enough to challenge the dragon that guarded the Golden Fleece. I had tried to imagine the instrument with which the god drew savage animals from hiding. charmed the birds from the air and made even the rocks lean forward to hear his primeval melodies.

This at last was a lyre I could believe in. Silent now for a hundred years since it was brought from the hills of Nuba. we do not know the tunes it played; yet the festoons of beads. cowries and tokens hung from its crossbar tell their own tales of miracle. In its life in the Sudan it was used in rituals of cure and its player had the role of exorcist. It would have sounded throughout the night. accompanied by drums in the firelight. until

trance was induced in the dancers: that state in which tormenting spirits could be driven out. Each successful conjuration would move the healed villager to pay tribute to the instrument: women with their finest beads and men with coins and amulets. winding them around the already crowded strut to give it yet greater power and prestige. Even rosaries hang from it as if in homage to older and more animistic forces.

I was not alone in my reaction. When I showed the photo I had taken in the storeroom to Harrison Birtwistle (whose opera *The Mask of Orpheus* revives and reexamines the myth for our own time) the same name sprang to his lips. not only. he explained. because of the barbaric splendour of the metre-high lyre itself but because the seven strings are grouped as five and two: the original five being the ancient pentatonic scale and the other two. known as the Gift of Orpheus. the additional notes that make up the octave (i.e.. seven plus the first repeated).

The lyre in Poussin's engaging painting represents the great fallacy of Classical art: we forget that the deities of the old mythology were not themselves *of* that time. but of an imagined earlier state of man when gods were gods and magic lyres drew tears from listening stones.

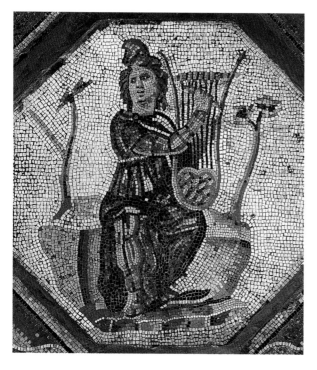

Orpheus Charming the Animals Roman mosaic, 2nd century AD Lapidary Museum, Vienna

Nicholas Poussin (1594–1665) *A Dance to the Music of Time* (detail) c.1639–40 oil on canvas Wallace Collection, London

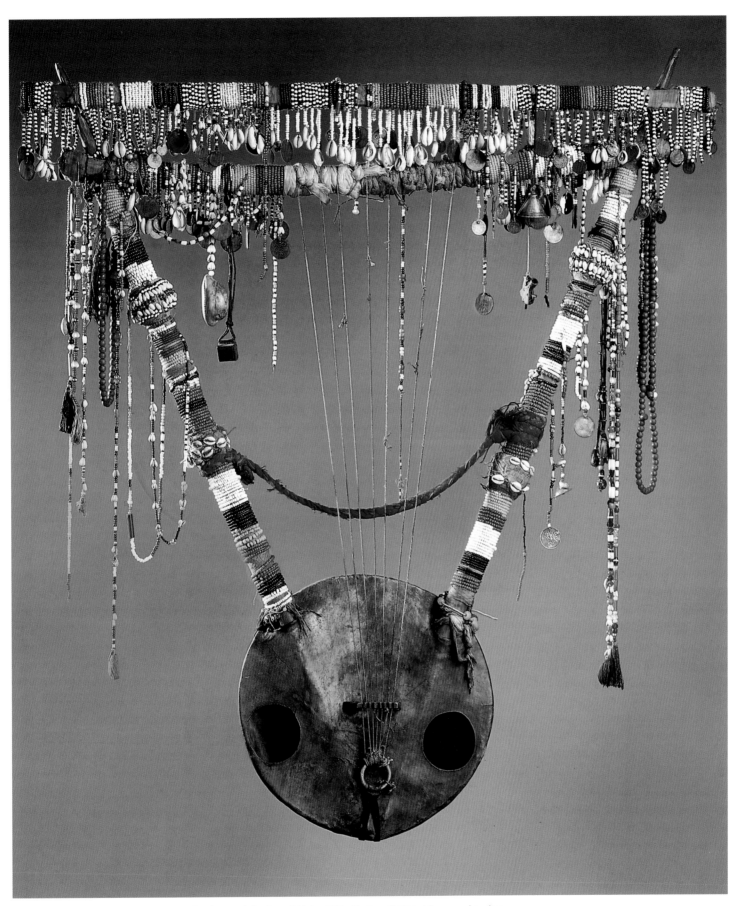

Unknown artist, *Lyre*, 19th century, mixed materials, found Nuba Hills, Sudan. British Museum, London

A Bankrupt of Substance

Public Relations has always been with us. Before photography, the painted portrait (and, of course, the almost mass-marketed engravings that derived from it) was the means by which 'statements' of style and eminence were made.

Though the music lover is ever tempted to seek in the features of a favourite composer the fiery genius which brought about the sublime works he enjoys, his search, especially in the eighteenth century, is often in vain. It is the opposite image that is being cultivated. Take away the predictable musical attributes of instrument and score, and our periwigged idols could be lawyers or physicians. The composer is attempting, after so many generations as a court lackey, to edge into the professional classes: this is what he wants most urgently to announce.

It is not until Beethoven's middle years that the public relations machinery starts to work in the opposite direction. Thereafter, the composer, who probably now comes himself from the bourgeoisie, attempts to disown its world of narrow ambition and cautious taste: he affects a natural disorder and a casual eccentricity that leads to the imagery of *La Bohème*.

Meanwhile, it is the strictly formalised portrait that holds sway, and Thomas Hudson's last picture of Handel, painted in the composer's final years, is its archetype. Although many times financially bruised and once bankrupted by the (then as now) merciless world of opera management, his social status has long been assured. He is, after all, the great Mr Handel who wrote the *Messiah*. The score is seen here not only as a reminder of the work that brought him

fame, but as a tribute to Charles Jennens, who provided its text and who commissioned one of the versions of this portrait. The same score is included in Hudson's earlier picture of Handel and looms large in the marble rhetoric of Louis Roubiliac's memorial sculpture in Westminster Abbey.

Hudson was the leading portrait painter of the century before his eclipse by his own pupil, Joshua Reynolds. There can be little doubt that, contrary to the usual practice of successful portraitists of that time, he painted the silks and satins of Handel's opulent costume himself. The senatorial figure is set off by an Italianate arch that evokes Handel's forty-six operas, rather than the oratorios which succeeded them. It makes for a career summary of inspired simplicity, also providing a gentle indication that, for the blind maestro, the light is now behind him in his remembered past.

Mercier's picture, for all its comparative lack of accomplishment, is a more private glimpse. This is Handel at work: the notoriously full wig he favoured is out of sight on its stand. Such shaven-headed images (a genre of the time) have become difficult to read as social indicators and, in fact, we are more at home with artifice. Despite the informality of the pose and composition, the face is as closed as ever.

While such icons tell us what Handel looked like or, rather, how he wished to be seen, we have to turn to verbal descriptions by friends to have any inkling of the impression he made (contemporary caricatures merely single out his gluttony and resulting corpulence).

Dr Burney stresses his humour and energy and the polyglot jokes that led to so many Beecham-like anecdotes. Of Handel's demeanour, he writes: '[his] general look was somewhat heavy and sour but when he did smile it was as his sire the sun, bursting out of a black cloud, there was a sudden flash of intelligence, wit and good humour which I hardly ever saw in any other'.

The cloud does not break in any of the portraits. PR in its eighteenth-century form preferred straightforward gravitas, and Hudson, the arch-professional with his line in austere grandeur, was their man. Handel looks bleakly on us with sightless eyes for ever.

Philippe Mercier (1689–1760), *George Frideric Handel*, c.1730, oil on canvas. Private collection of Viscount Fitzharris

Thomas Hudson
(1701–79)
*George Frideric
Handel*
1756,
oil on canvas
National Portrait
Gallery, London

The Rapturous Tambourine

Call no instrument innocent. From the ever receding dawn of its history (now, after recent finds of a Neanderthal flute, shifted back almost half a million years) music comes with magic hoarded in its sounds. The devil tried many a savage instrument before settling on the violin as his final home. Men have gone mad and women have danced themselves to death to the tunes of bone and skin, hair and gut, reed, bladder and stick. It was after all only a harmless-looking pipe that Hamelin's children followed, skipping their way to oblivion. But the unlikeliest suspect in the field of hell-raising must be the shallow flat drum with resonators (little more than a skin stretched over a hoop of wood) and its formalised relative, the almost trivial-seeming tambourine.

I should have been warned in childhood when every Saturday morning, while my parents did the shopping, I stood fascinated at the corner of a suburban market listening to the firm cadences and rectangular rhythms of the Salvation Army. There, always emphasising the treading of the grapes of wrath or encouraging the onward march of Christian Soldiers, was an exultant (though whey-faced and bespectacled) spinster thumping a tiny tambourine high above her head. The singers were jolly in an earnest kind of way, but she alone was transported. I did not then know that she who raised our spirits on a rainy day was merely the latest in a line of female devotees stretching back into deep antiquity and that her half-naked forbears had, with

Filippino Lippi (c.1457–1504), *The Adoration of the Bull God* (detail), oil on canvas. National Gallery, London

that same instrument, summoned dark Arcadian gods.

Later, of course, I saw that no ancient vase or classical sarcophagus lacked its tambourine-playing nymph. This was the sound that the abandoned Maenads, the priestesses of Dionysus, danced to in their frenzy. With such dangerous credentials the instrument had no option but to become an outsider (an aspect most recently evoked in Bob Dylan's famous song) and take to the streets. These itinerant Roman musicians are in that vagabond tradition. Their casually garlanded heads, as well as the mask of their piper (or aulos-player), still evoke the cult of Bacchus.

This mosaic, part of the teasing treasury of Roman art preserved by the catastrophe of Pompeii, shows absolute mastery of roundly realised, full-bodied life. It is one of the provincial masterpieces that gives us a hint of the quality of the lost pictorial art of Ancient Rome. If a mosaic in the Roman equivalent of Bognor Regis can be of this order of accomplishment, what must have been the quality of the paintings in the Empire's capital?

When the artists of the Renaissance (a thousand years later) wished to evoke the ecstatic excesses of an imagined past,

Dioskourides of Samos (2nd century AD), *Street Musicians, from the Villa of Cicero, Pompeii.* Museo Nazionale, Naples

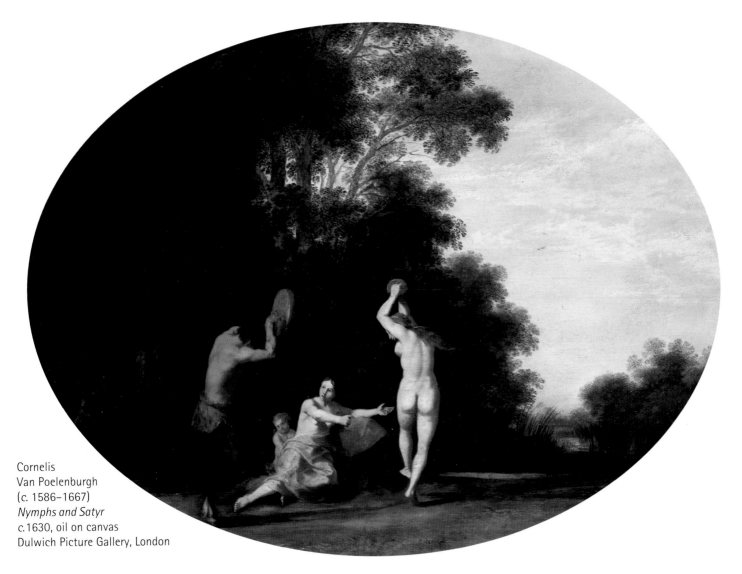

Cornelis
Van Poelenburgh
(c. 1586–1667)
Nymphs and Satyr
c.1630, oil on canvas
Dulwich Picture Gallery, London

they also reached for the tambourine.
Filippino Lippi, in an enigmatic picture
which seems to depict an Oriental bull
cult in action, cooks up his antique instru-
ments from engravings of Classical reliefs.
As authentic and unchanged in his own
day as this, however, is the ubiquitous
tambourine, which appropriately is here
played by the most tranced of the dancers.
She is already far gone and, judging by
her knife-wielding companions in the
picture, has further yet to go.

The associations of this most nearly
toy-like of instruments with moments of
dangerous possession in religious rites is a
constant in art. It is not surprising that in
Raphael's painting of St Cecilia (cf. p. 29)
we find that the tambourine lies amongst
the shattered instruments at the feet of

music's patron saint, rejected in her bid
for purity. Even in that most bourgeois
place and time of the history of European
painting, Holland in the seventeenth
century, it can be found in the midst
of pagan mystery.

Poelenburgh's miniature epiphany
has long been one of my favourite pictures.
Every time I see it in the Dulwich Picture
Gallery I am struck by its odd matter-
of-factness. It is as if Poelenburgh, an
ordinary sort of a chap, out for his usual
walk with a stick and a dog, suddenly
had come upon this little scene and, on
returning home, had sat down quietly with
his pipe and paints to commit it to canvas.
It is the least flamboyant version of sylvan
mythology possible. The tap of the drum
and the jingle of the tambourine are all

that are heard in the silent clearing as the
little group of satyr, nymph and dervish
go about their ritual business. For all its
well-mannered style it has the directness
of prehistoric cave painting. Full trance is
near and at any moment from the sombre
trees the Great God Pan will emerge.

Music and Movement

To exist at all music must start by exciting the air; it is an art innately full of movement. One joy of concertgoing is to see the actions generated by the score as they generate in their turn the sounds we hear. Although we may not be able to read the notes we can 'read' the playing of them.

Perhaps that's why my little black box gathers dust, for I play almost no recorded music: my eyes have nowhere to go (and dislike bouncing red stripes). In the concert hall we browse the orchestra or focus on section or player at will. Televised concerts are maddening in that they bully us into viewing the trumpeter when his moment is cued, the choir when it enters, etc., whereas we might in life prefer to apprehend the trumpet entry while looking at the strings: we are robbed of personal choice and our responses are pre-empted.

Painting has its problems here since it can only imply motion, though it can be clever in embodying the potential of movement, or, with slight blurrings, indicate the animation within a frozen moment.

Occasionally, as with Delacroix's little paintings of Paganini (cf. p. 97) or one of Picasso's Cubist guitar players, a certain flickering ambiguity can convince us that nothing is in the same place as when we glanced at the picture last. But all attempts to portray movement through time are doomed: they tend to end up reminding us of photos that went wrong.

The Italian Futurists, for all their manifestos extolling the glory of the machine in the new aggressive age of speed, and for all their own combative music experiments (in a nutshell the ideal of Futurist music would be the noise of bombs destroying the Louvre), tended to make mere confusion when they tried to show simultaneity. There is something unavoidably comic in a dog with twenty-four legs attempting to persuade us that walking looks or feels in any way like that.

Even a gifted artist like Balla has to deceive us by drawing multiple positions of the violin's scroll in order to accommodate the various arrangements of the fingers. The bow is a shivering token and the background itself joins in by being queasily a-quiver. The curious format of the painting signals the artist's admission that he has painted himself into a corner. To depict any more of the performer would be fatal. The motion, if any, that we experience is the wrong one, for the effect is that of nodding our head vigorously while watching someone playing the fiddle.

The strong hands of Rameau look as if they could certainly command the instrument he holds. We sense both some movement in the delicately fuzzy hand that brushes the strings and a capability of any one of the fingers on the other to land firmly on a note. There is more energy in Rameau's repose than in the graphic agitation of the Balla: all the more in fact because the rest of the picture conveys the

Jacques Aved (1702–66)
Jean-Philippe Rameau
c. 1730, oil on canvas
Musée des Beaux-Arts, Dijon

Giacomo Balla (1871–1958), *The Hand of the Violinist*, 1912, oil on canvas. Eric Estorick Foundation, London

composer's modest yet questing personality and thereby depicts true human animation (i.e. motion of the spirit).

The feat that eludes painting is natural of course to the cinema. This same subject was once brought off in spectacular fashion in *They Shall Have Music* (1939), a mawkish tale which features the greatest violinist of this century, Jascha Heifetz, as both actor and musician. All is forgiven Heifetz the actor, when he at last takes up his violin. The astonishing full-screen shots of the massive engine of his left hand with its huge digital pistons homing infallibly on the strings out-futurises the Futurists as a dream of mechanistic splendour.

The credits reveal the secret: a second great artist at work, in the person of lighting-cameraman Gregg Toland (who was later to make *Citizen Kane* with Orson Welles).

This is movement captured by the medium designed for the job, yet what is most haunting about these long sequences (the film does not suffer from TV's apologetic restlessness and failure of nerve) is the absolute stillness at the heart of activity. Nothing moves that does not have to and one is more reminded of Rameau's capable solidity of hand than the dowsing rod attacked by a falling prawn that Balla serves up.

59

The Wagnerites of Provence

Genius and mountebank were sublimely combined in Wagner, who was fond of a sweeping theory. His dream of a *Gesamtkunstwerk*, that comprehensive work of art in which all arts were to be equal and united, was a grand idea except that he found some art forms more equal than others. He was in fact notoriously uninterested in painting and sculpture, for which his taste remained steadfastly bourgeois.

Artists themselves, however, thrilled to the lyrical, spiritual and pictorial implications of his mighty music dramas.

Vincent van Gogh
(1853–90)
*Marguerite Gachet
at the Piano*
1890, oil on canvas
Öffentliche Kunst-
sammlung, Basel

The Post-Impressionists, who grew up in his creative shadow, infected each other with an enthusiasm first trumpeted by Baudelaire in his evangelical pamphlet of 1861. This had been a battle-cry of modernism against the philistines who had catcalled *Tannhäuser* off the Paris stage after only three performances.

Although Fantin-Latour led the way with a sensuous confection based on the Venusberg music, it was Gauguin who became obsessed with the possibility of an equivalent figure to Wagner in the visual arts (he had himself in mind). His own reinventions of mythology (of the South Seas, a more hedonistic location than Wagner's spartan North) were part of that programme. The real reverberations of the music (rather than the stories) were, however, felt and communicated by two of the most passionate puritans of nineteenth-century painting, Cézanne and van Gogh.

As early as 1866 M. Marion, one of Cézanne's small social circle in Aix-en-Provence, wrote to their mutual and musical friend M. Morstatt, '... in a single morning he [Cézanne] has half-constructed a superb picture as you will see. It will be called the overture to Tanausher [sic] – it belongs to the future just as much as Wagner's music'. A year later, he was still describing the same undertaking (now in the second of three attempts) as containing an old man in an armchair and a child listening open-mouthed.

It was perhaps a larger exposure to Wagner's music that fuelled Cézanne with the courage and inspiration to make a final version, the surviving canvas of the three. In 1868 the artist heard, in a series of concerts in Paris, full orchestral performances of the *Tannhäuser* and *Flying Dutchman* overtures as well as the Prelude to *Lohengrin*. A month after the last of those concerts he was back in Aix and in front of his easel again.

What could be read as a scene of provincial domestic monotony, with a mother sewing and daughter strumming the long evening away, is transformed by its illuminating title. Suddenly the image's air of uneasiness takes on a different meaning. Emotional engagement, for which one searches in vain in the faces of its protagonists, is found instead in

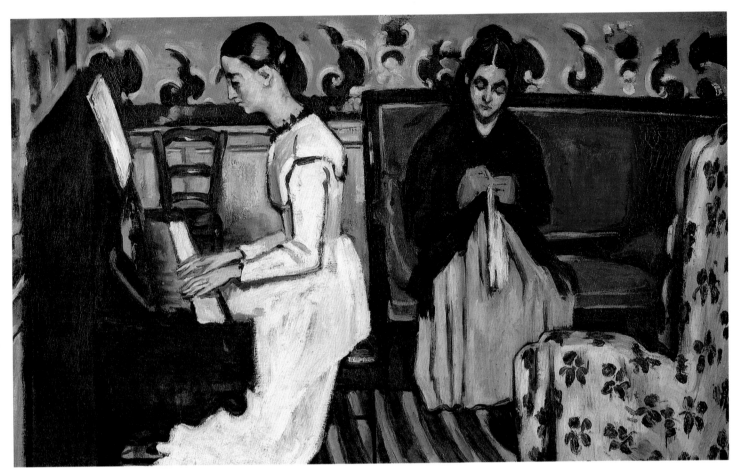

Paul Cézanne (1839–1906), *Girl at the Piano (Overture to Tannhäuser)*, 1869–70, oil on canvas. Hermitage, St. Petersburg

the insistent rhythms of pattern which flicker over wall and chair cover with a restlessness at odds with the rectilinear composition. Cézanne was always likely to invest objects and landscapes with more heightened feeling than the human beings he portrayed. He was a painter without guile or trickery: even in such an early work it is his rare instinct that makes him reduce the carpet's perspective so that its flattened stripes serve the picture's stability. If you cover them up, the painting seems over-alive with giddy decoration and flame-like arabesques. This is the essence also of Wagner's youthful music, where almost relentless four-square scaffolding supports ever more wayward and rhapsodic song. Cézanne was already a member of the Wagner Society of Marseilles before he started the work and what had been in his mind is best mirrored in the words he wrote to Morstatt in 1865. He begged his friend to come and play to him and 'cause our acoustic nerves to vibrate to the noble accents of Richard Wagner'.

Not far from Aix, and twenty years later, van Gogh was writing excitedly to his brother Theo of his quixotically ambitious determination to 'learn music' so that he could explore 'the relations between our colour vision and the music of Wagner'. Van Gogh had found in Dr. Gachet the solid friend he needed, as well as a sympathetic doctor, and it was perhaps in the Gachet house (the doctor was also a friend of Cézanne) that he first experienced some of Wagner's music at first hand. It would be surprising if the daughter of such a progressively cultured family had not been a reasonably accomplished amateur player of the new music. Van Gogh's touching portrait of her is, like Cézanne's painting, an example of a calm domestic image full of paradoxically fiery energy.

The pose, albeit from a different angle, is identical to that of Cézanne's young woman at the piano (the model for whom was possibly his sister Rose, to whom he eventually gave the finished painting). Van Gogh, however, vivifies every part of the picture's surface. Its rhythm is carried, as ever by an artist who has no rival in expressivity of gesture, by the brushstrokes. They swoop around the folds and forms of the dress, bearing with them all kinds of unlikely pinks and blues and yellows. To frame these lyrical ripples of paint, the brush makes a dark staccato of the floor and with a scattered punctuation of red, warms the green wall into life. As with Cézanne, there are no tricks. It is a marriage of contrasting calligraphies that, like automatic writing, conveys simultaneously the nervous and intellectual responses of artist to subject.

With Cézanne's canvas we have the title to tell us what is being played (even though the pianist could hardly have performed, as in some marathon, the same piece over and over again). No such hints are given by van Gogh, yet it would not be fanciful to suggest that in both pictures the notes of the *Tannhäuser* Overture passed through their making, in actuality as well as in spirit. Neither piano gives anything away, since each music stand supports a noteless score.

61

Signs of Musical Life

This familiar if uneconomically florid sign has become shorthand for music itself. In the last week I have seen it scattered over a tea-towel and as the shape of a bent novelty pencil. It is ubiquitous in the world of key-ring and tie-pin as well as being in constant graphic use to advertise all sorts of musical products and enterprises. Like the crotchet and quaver it floats free of function and context to announce that music is the matter in hand.

For all its common currency it can prove quite difficult to draw: one twirl too many makes it over-ornate and a false start often has it perilously leaning one way or the other. In essence it is an engraved mark, elegantly formed of upstrokes and downstrokes of varying width in response to the pressure on the graving tool. In early notation all sorts of devices were tried out to signal the whereabouts of a particular note on the lines of the stave. Only three main types survived and once engraving became the means of printing music in bulk these became fixed flourishes, suited to the tool and the metal and the calligraphic style of the dawn of the Baroque. Since the function of this signature is merely to locate, by its central finial, where G is on the stave, almost all the curves and embellishments are entirely superfluous: any clear mark would have served just as well.

Thus it is a semiotic fossil travelling from the handmade score to the computer. Self-evidently it was not designed with pixels and image digitalisation in mind, yet it is, one assumes, destined forever to denote the G clef and hence the treble clef.

Though more usually the plaything of graphic designers, it has made guest appearances in art, especially in the twentieth century. In these two instances it occurs unusually as the entire subject-matter of a work.

Josef Albers, like Paul Klee, was one of the great Bauhaus teachers and his work as a painter often seems almost an extension of his educational role. His series *Homage to the Square* is still regarded by students as a young person's guide to colour harmony. In book form it stands as an exhaustive treatise on tonal and harmonic arrangements, an inventory of chords of colour. In the same manner he produced, as if by way of relaxation into the world of curves, a shorter series of variations on the treble clef, identical in format but with strikingly different combinations of colours giving contrasting moods: bright, romantic, cheerful or, as here, lyrical, and (in blue and red) unstridently forceful.

Niki de Saint Phalle is a more fun-loving artist in every way and has been responsible for the final release of public sculpture from the domain of memorialised worthies. The popular *Stravinsky Fountain* by the Pompidou Centre in Paris pays tribute to the composer's works and themes via huge and brightly coloured figures, animals and shapes (the clown of *Cirque* can be seen in the background). Each also serves as a fountain. The whole work is akin to a water opera and was made in collaboration with Jean Tinguely, the modern grandfather of musical mechanism, the twangs and clatters of whose sound-making machines enliven many a dour art museum.

In both works the clef is subject to small variations. Albers with uncharacteristic whimsicality adds a loop to the upper strokes of the symbol in order to catch another colour area for the top of his picture. Saint Phalle, as well as using the pumping apparatus as a sharp sign, incorporates a plate for the water to strike, like a residual piece of a stave-line it cuts through the curves and provides, via splash and trickle, another element of the water music.

Both in the austerity of Albers and the playfulness of Saint Phalle the artistic imagination breathes life into this relic of ancient notation, to keep it from the Home for Tired Signs.

Jean Tinguely (1925–85)
& Niki de Saint Phalle (b. 1930)
Stravinsky Fountain
1983, aluminium, fibreglass
and polyester
Centre Pompidou, Paris (outside)

Josef Albers (1888–1976), *Violin Key 7 & 8*, 1935, gouaches. Josef Albers Museum, Bottrop, Germany

Genius Paints Genius

Here is a strange case of three great composers united by portraiture. Only two paintings are involved, an ocean apart, and separated by three decades. The pupil is painted by the master, who in turn is portrayed by the admirer and would-be disciple. Between them they created three of the seminal masterpieces of modern dramatic music: *Moses und Aaron, Wozzeck* and *Porgy and Bess*.

Alban Berg came to study with Schoenberg in 1904 at the age of nineteen, after some dithering between the muses of poetry and music. The languors of *fin de siècle* poetry are still present in the faraway gaze of the young man, and in the painfully insouciant pose (Berg's left leg would be numb after half an hour), yet at once it can be seen as an affectionate work. Its open and frank presence speaks eloquently of the bond of friendship and trust that soon established itself between the two.

Alone amongst the canonical composers Schoenberg was a distinguished painter in his own right. His works hang in art museums all over the world, usually pictures from the visionary series of tortured heads he painted over a long period, some of which (despite their closed mouths) out-scream Munch's famous icon in their

angst. Their high quality as likenesses can be seen in a photograph of the composer/painter with self-portraits where all four heads have in common a haunting stare. The portrait of Berg is doubly rare in its domestic relaxation.

Like most artists' money-making schemes, Schoenberg's plan to subsidise his musical activities with portrait painting never came to very much. At one time, with the help of friends, he even solicited commissions, at a fully professional fee.

The problems of tonality in painting are not so constrained as those in musical composition. They are more a personal matter and it is the individual tonality of a Rembrandt, a Tiepolo or a Renoir that allows us to identify their work across a wide gallery. Schoenberg's adventures in painting reinforced by his long discussions with Kandinsky (who was his fellow pioneer in tackling the problem of abstraction), must have given strong reassurance in a struggle to break down traditional barriers.

Like Kandinsky he was to turn new-found freedoms into rules; but that is the way of art. Artists seek alibis in systems for what they wanted to do in the first place. It is Schoenberg's painting that most clearly tells us that, for all the edifice

of theory, he was the purest example of Romantic expressionism.

No such anguished pictorial scruples troubled George Gershwin, to judge by his rather stiffly painted head of Schoenberg. All is changed; nothing so announces the amateur as the presence of all the right equipment, even down to the freshly pressed smock. Berg and Vienna are far away, and the ageing master will outlive this young man as well.

A strange situation of mutual envy now links sitter and painter. Schoenberg, who would have liked his immensely respected music to be more spontaneously loved, is portrayed by Gershwin, who desired his only too well-loved music to enter the realm of high seriousness (and this publicity photo is a part of his revised credentials). The theme is familiar to Schoenberg's future audience, for here we have Aaron painting Moses.

George Gershwin (1898–1937) at work on a portrait of Arnold Schoenberg

Arnold Schoenberg
(1874–1951)
Portrait of Alban Berg
c.1910, oil on canvas
Historical Museum
of the City of Vienna

A String Struck Long Ago

Dutch painting is alive with music, from the bourgeois ladies at their eternal virginals to the rough tavern-goers carousing to bagpipe and fife. Yet, despite his rich harmonies of paint, whose Brahmsian sonority seems anchored by basses and cellos and the lower brass, Rembrandt himself rarely depicts the act of music-making.

The exception in his work is an Old Testament subject that he returned to more than once, where the young David plays the harp to relieve the aching depression of Saul, first king of Israel. The psychological reverberations of the situation are echoed in the musical event for, though Saul has intimations that the shepherd boy will gain his crown, it is only David's presence and artistry that can ease his heavy

heart. Thus the malady is cured by its cause. The complexity of this convoluted bond dares Rembrandt to an outrageous composition, which Saul (occupying half of the picture) dominates but David (squeezing into a bottom corner of the image) controls. The rest is not silence but sound, and Rembrandt meets the challenge of picturing that sound by showing both its effect and origin: the latter by painting magic hands.

David's right hand is relaxed in quiet accompaniment, the graceful alternation of the fingers augmented by a hint of rippling drapery behind (which serves almost as the cartoonist's device of additional marks to imply movement). The left hand, whose motion is hinted at by a deliberate anatomical uncertainty,

Hands of a harpist: fragment from tomb, Valley of the Kings, Egypt (c. 1305–1080 BC)

Jean-Baptiste Mauzaisse (1784–1844) *The Harp Lesson (Mme Genlis)* c. 1820, oil on canvas Versailles Museum

exhibits greater pressure, and its strong middle finger has just plucked a particular string whose note now travels across that thickened air so characteristic of the glowing dinginess of Rembrandt's pictorial space. It is this plangent turning point in the melody that moves the king to forget all regal formality as he gropes for the curtain to dry his eyes. With Saul's hand thus hidden three hands remain to tell us the story. At the bottom of the painting, David's are at their mesmeric work while, unconsciously (and emblematically signalling his destiny), Saul's right hand lets slip the staff of his kingship. It is a triumph of artistic economy achieved by painted reticence. What other artist would have the courage to leave the whole central area of the picture virtually blank, to be occupied by a note? Compared to the tangible presence of David's playing, all the ladies at their virginals are merely posing and all the pipers in taverns are mute, puffing their cheeks with stagy zeal.

The polite world of the harp as it became an instrument of boudoir and salon (rather than angelic choir or barbaric court) is all too elegantly captured in the painting by Mauzaisse of the talented beauty Stephanie Fellicite Genlis (who was admired by many and also sat for

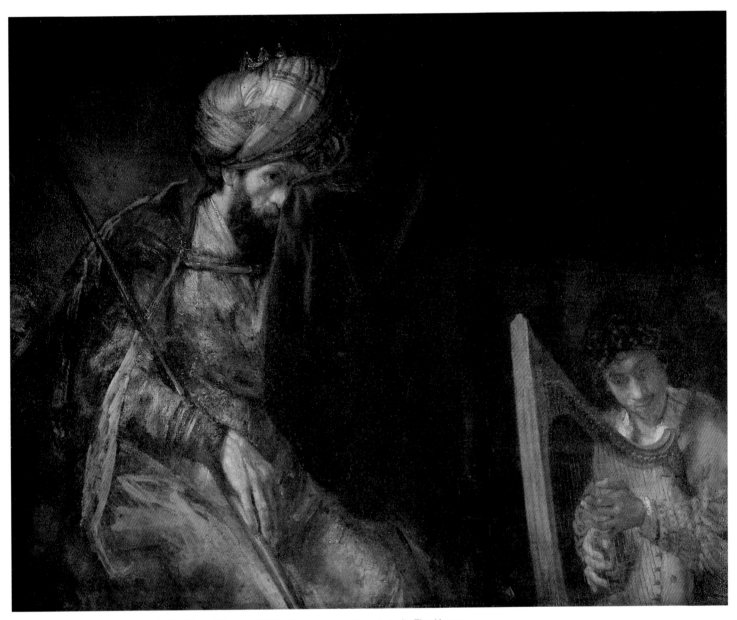

Rembrandt van Rijn (1606–69), *David and Saul*, c.1658, oil on canvas. Mauritshuis, The Hague

Romney). She is seen here giving a harp lesson to her daughter and Princess Adelaide. The diminutive princess is at full stretch in the piece they are playing though perhaps her mind and attention are on us rather than the music: the daughter pays full and obedient attention to her mother. Her finger positions look professional and correct but to the artist they are merely positions, held no doubt long enough for him to get the hands right. The picture, despite the presence of two harps, records costume and posture

(with particular attention to improbable headwear) rather than sound.

In order to hear fingers make living and sonorous contact with strings again we must travel back to the time of David's actual encounter with Saul three thousand years ago.

The intimate and light-hearted side of Egyptian art is too little known, dwarfed as it is in museums by the fascist monumentality of pharaonic propaganda. Informal drawings are to be found on innumerable pieces of discarded stone

(*ostraka*) some used semi-officially to show a student how to depict this or that deity and others for sketches of animals or caricatures of fellow artisans.

This is altogether more jaunty harping, and the brilliantly drawn hands anticipate a cartoon tradition that leads to the musical fantasies of Hoffnung. The work of a virtuoso, it could not have taken more than three or four minutes to make: yet it calls up a tapping foot, a chorus line of seductive Nubian girls, a diverted pharaoh and a queen, perhaps, who is not amused.

67

The Ring & the Comic Book

Wagner, like Shakespeare, is robust. He is the ultimate punchbag for aesthetic bullies. However hard you hit him with production eccentricities and 'concepts', he springs back intact, ready for the next blow.

The Ring can be set in the jungle or among post-nuclear ruins, in the Wild West or on Planet X, without damaging the story's enactment. This will always be as foretold by the fate-weaving Norns (who themselves may appear as muses or furies or members of a Women's Institute). Whether Siegfried enters as Tarzan or Buzz Lightyear, in *Lederhosen* or a three-piece suit, his triumphs and doom are so strongly lit by magnificent music that such details are soon forgotten.

Neither are there any absurdities of illustration that Wagner escapes. In Wahnfried, the Bayreuth shrine that was the home of the composer and his wife Cosima, the walls are lined with a hundred years' worth of successive pictorial transcriptions of Wagner's dramatic world. Each vies with the other to be definitive (as indeed they all are of some facet or other of such panoptic works as *Parsifal* or *The Ring*). Downstairs the various set designers add their visual footnotes from early Pre-Raphaelite dream-worlds to the minimal austerity of the settings produced by the composer's gifted grandson Wieland.

The Ring is a dragon's cave for the artist. He steps into it at his peril: only the hardiest or most innocent survives. Of the latter, the homespun hero of American art, Albert Pinkham Ryder (himself a kind of Parsifal or Holy Fool) comes near Wagner's own visualisations as hinted at in the first productions. The deliberate waywardness of Ryder's technique has left us a group of darkened and ravaged canvases whose poetry still shines through their fractured surfaces. Often he would work on a picture for over a decade. Even when he sold one he might well ask for its return to make a further attempt, with spittle and chalk, bootblacking and unstable oils, to realise his initial imaginings in darker darks and more piercing highlights.

Ryder is perhaps still the greatest artist that America has produced and certainly the finest visionary master of sea and cloudscape in the history of painting (a turbulent reverie on *The Flying Dutchman* was the first of his Wagner tributes). This evocation of an episode from *Twilight of the Gods* may have been inspired by the premiere American production at the Metropolitan Opera in 1888 (the dates of his paintings are elusive). All we know about its genesis is that he described to a friend how he returned from the opera and 'for forty-eight hours without food or sleep' worked on this image. Although years of refining no doubt followed, the story conveys the effect on his spirit of the most avant-garde music of his day. He had gone with his friend Inglis who leased a box at the Met. Although Inglis himself thought Wagner's music drama had 'too much sauerkraut in it' he was the unwitting midwife to the first American masterpiece on a Wagnerian theme.

The work is a perfect analogue to the moment in *Götterdämmerung*. The narrative is clear and Ryder at first glance seems merely to be describing Siegfried's meeting with the Rhinemaidens, who try to tease him out of possession of the ring. The figures are, as it were, the bare bones of the libretto: the rest of the painting is the music. The jagged sky in counterpoint to the undulating trees speaks all the anxieties of the score in this final battle between choice and destiny. The natural forces at work, and the dark wind that twists everything into metaphor of a tumult to come, prophetically dwarf the agonists of the scene. As in the opera the orchestra, acting as a huge lens to magnify the drama, tells a grander tale than the action.

Not so far away from Ryder's version of Wagner's timeless Teutonia and its (largely invented) myth is one of the best (if silent) productions of *The Ring* made in recent years. The fidelity to text and mood of DC Comics' strip-cartoon rendering makes it a most helpful introduction to the cycle. The modern comic book is produced, like a Renaissance mural, by a team and with not dissimilar division of labour. Here the story is adapted by Roy Thomas and the drawings are done by Gil Kane. Colouring, always a separate and specialised procedure, is by Jim Woodring, with lettering executed by John Costanza.

Naked Rhinemaidens, in the late twentieth century, are at last free to advertise pneumatic bliss (as can be seen in the frame from *Rhinegold*), with all the provocation that Wagner must have dreamed of.

When towards the end of their four-volume cycle Thomas and Kane's narration coincides with Ryder's canvas, the characters are similarly grouped. Siegfried, however, is now on foot, as he is (much to the relief of stage directors) in the opera itself. In successive frames we see the encounter from different points of view (including that of hero and aquatic

The Ring, Götterdämmerung (left), *Das Rheingold* (right)
Drawings by Gil Kane
Colouring by Jim Woodring
Lettering by John Costanza
Story adapted by Roy Thomas
Publisher: DC Comics

68

Albert Pinkham Ryder (1847–1917), *Siegfried and the Rhine Maidens*, 1888–91, oil on canvas. National Gallery of Art, Washington, DC

temptresses): this emphasises the close relationship of comic strip to film whose devices of close-up, long-shot, and so on, it uses so inventively. Only the painter must distil all subjectivities into a single image.

The word comic suggests a cheapened form of storytelling and a vulgarisation of a theme. The present-day comic book is far from that and is more typically addressed to adults rather than children. It is taken very seriously by the French, who are always first to spot (as with Hitchcock's films) high values in low genres. The DC Comic is a classic of its authentic American kind. Wagner would have been delighted with its vigour and dramatic wit. He would now more likely have trouble with some contemporary stage versions (although he expressly welcomed a future of radical productions of his work). Whatever the vagaries of taste and fashion in interpretation, his mighty conception, though the object of many assaults by competitive egos, remains a series of unconquerable peaks. What do the Alps care about shifts in the weather?

The Quest for a Painted Voice

To show that the singer is singing has always posed a problem for artists. The painters of early miniatures depict people with large holes in the fronts of their heads whom we know to be singing (rather than yawning) only from the instrumentalists that surround them. These holes become progressively more refined in the history of art, as here in the famous group of music-makers from Piero della Francesca's *Nativity*. One singer sounds an open vowel, it seems, and the other a more closed one (as if in fact the artist wanted us to think that in the presence of the Virgin they were singing the word 'Ave' between them). But even in the hands of a great master like Piero the process of singing is indicated more by the presence of other musicians than by the physical depiction of voices in action. The different vowels also tell us they are singing in harmony with their accompaniment of two lutes and a rather indeterminate bowed instrument. When we cover up these instruments, however, all that we can really say is that one of the singers is shouting perhaps and the other merely gaping.

The little ensemble provides in Piero's customarily calm and temperate world a harmony within a harmony. So silent is the space when we enter his pictures and so mute the great majority of their protagonists that Piero might well have been called the Master of the Closed Mouths. Singing is a bodily motion yet it would have been inappropriate to have these angels straining for their notes: they are here as emblems of their activity. One other open and decidedly unangelic mouth adds a third part to the song. The braying ass is visually linked to the quintet, its mouth in line with that of the other vocal performers, as if to say that Nature must also lift its voice in praise of the new-born Christ. How this would sound with such a delicate ensemble in the winter air is difficult to imagine. Piero keeps it all in check with his complex geometries and muffled colour.

Four hundred years later Degas, that great portrayer of dance and music, gives us the business of singing with an almost brutal degree of frankness. Here is 'Naturalism,' where throat and body are totally at work to produce a sound as calculatedly unrefined as the red, green and yellow stripes that Degas cunningly introduces as an accompanying chord.

The artist brought the singer to his studio to draw her by daylight in her stage costume. In this final pastel he rearranged the lighting from memory to match that of the music-hall stage. So much for naturalism, which of course is only high artifice in a new disguise: the artist's picture is every bit as contrived and rehearsed a performance as that of the *artiste* he portrays (in what must be one of the loudest pictures of a soloist). Degas has heightened the dynamic, the pitch and the drama of the song with a virtuosity that preaches the eloquence of awkwardness.

The moment at which the mechanics of singing expresses itself to sight is hard to catch. Almost every frame in a film of a song being sung is ugly when divorced from the sound and its continuum of facial gesture (just as the snaps we take of a loved

Edgar Degas (1834–1917), *Singer at a Café Concert,* 1878, pastel on canvas.
Fogg Art Museum, Cambridge, Massachusetts

one smiling with engaging grace turn out when we open the packet to be a disappointing set of smirks and sneers). Realism is all very well, decides the Publicity Machine as it hurries back to Piero's world of emblem. Many famous singers now pose with mouths tastefully and soundlessly open. Not a muscle is stretched or an expression strained as the world of representation (at the mercy of vanity) turns full circle.

Piero della Francesca
(c.1419/21–1492)
The Nativity
c.1470, oil on panel
National Gallery, London

The Geometer of the Dance

Now that one can buy a Mondrian tea towel in Woolworths, his art may no longer be thought of as difficult. A student might even be tempted to pick up where he left off, arranging simple elements in an aesthetic way. Easy. But the distillations of maturity are a trap for youth. Pastiche is what follows; the imitation of the container without the contained, as with those composers who think that the cadences of Satie can be extended into infinity. A look backwards through Mondrians's work shows what a wealth of rumination (theosophical enquiry, analysis of nature, etc.) was brought to this quintessence.

It was no light-hearted business to leave the world of reference and, with no public or critical encouragement, to cross over into unknown territory. Music possessed the enviable privilege of being self-contained, unobliged to refer to a world outside itself. Thus, for the two great pioneers of abstraction, Kandinsky (cf. pp. 38, 39) and Mondrian, it offered a bridge across the chasm. Bach and his fugues (which asserted music's almost visible architecture) provided both artists with a handrail. Mondrian made what must seem in retrospect an inevitable series of stately moves towards distilling experience in an austere game involving primary colours and only two graphic signs, the line and the rectangle. These well-known works look more spartan and mechanical in reproduction than in reality where the paint is seen to be handled with nervous sensuality. This facture (the artist's equivalent of timbre) plus a flattening of the primary colours with a small admixture of black gives the pictures, which seem to be done so unremittingly in major keys, subtle inflections towards the minor.

Mondrian was obsessive in everything. Hating green, he would paint the stems of tulips white before placing them in the studio that he designed as a three-dimensional equivalent of his paintings. He applied himself with characteristically compulsive diligence to ballroom dancing, at which he apparently excelled. From Holland he moved to Paris and eventually to America. With each move his world was expanded by jazz, which became his paradigm of modernity. New York, with its grid of streets enlivened by strict tempo bustle and pulsating neon, appealed to him enormously and it was there at the end of his life that he produced the most successful transcriptions of musical experience ever made. The sedate measures are suddenly syncopated as the jazz-lover makes silent jazz and the dancer yields to the dance. We have left the cloister for a bar, where (as the artist himself describes) 'there is nothing to tie one to the old . . . the building, the lighting, the advertising cooperate directly, in their commingling, to the production of the rhythms of jazz'.

To indicate the difficulty of making music in paint, one can look at the work of Johannes Itten who, together with Klee and Albers (cf. pp. 27/63), was a distinguished teacher at the Bauhaus. His day's work would begin with the playing of Bach to establish the frame of mind for organised abstraction. His *Blue-Green Sound*, with

Johannes Itten (1888–1967), *Blue-Green Sound*, 1917, oil on canvas
Kunsthalle, Bremen

Piet Mondrian (1872–1944), *Broadway Boogie-Woogie*, 1942–43, oil on canvas. Museum of Modern Art, New York

its radiations and cross-currents, is full of pictorial pleasures in what was already by the end of the First World War an international abstract mode. The search for visual equivalents to match musical impressions leads it, however, into illustration, a genial evocation of the enjoyment of melody and harmony.

Whereas one can look at the Itten as a mood-piece which time has turned into decoration, Mondrian's late masterpiece is still active, its lights undimmed, its beat still keeping the eye in perpetual motion, and its vibrant intervals still precise, eternalising the rhythmic moment that visitors to New York still experience when

they suddenly feel at one with that city's heightened momentum.

Itten is painting his response to music, yet for all the work's attractive patternings, no sound comes to us. The seventy-year-old Mondrian pictures music itself in the only painting in the world that can set one's foot tapping.

Early Illuminated Stars

The cult of personality in music gets off to an early start. In mythology's fine and misty times the gods (Apollo, Krishna, etc.) make music and the heroes (Orpheus, David, Siegfried and so on) are seldom without an instrument. Thereafter the musician lapses into a long anonymity amongst the numberless pipers and fiddlers of folktale and popular legend.

Individuality makes its comeback in the Middle Ages amidst the grand and luxurious courts where the musician starts to thrive. Occasionally he even emerges as an international figure whose fame allows him to sell himself to the highest bidder. This evolution culminates in the cultivated persona of Beethoven whose absolute independence makes him grander than any court he might serve. He declares the true aristocracy of genius in his black visiting card on which is calligraphically embossed the single word "Beethoven". Perhaps the final emancipatory step is taken by Wagner who turns the tables on the nobility by drawing his patron Leopold into willing servitude as if now it is the composer who confers favour and awards the honours.

Quite a distance has been covered since the time when stone musicmakers sprouted from the sides of cathedrals and unnamed players lurked with their carved shawms and sackbuts beneath the seats of the choir stalls. Even when such artificers of music were known by name they were represented by an iconic generalisation in the Byzantine identikit mode.

The great shift was in the fourteenth century which saw the emergence of giants in literature and art such as Dante and Giotto. In the world of music it gave birth to the Ars Nova movement and, appropriately it is its leading figure who first steps, fully characterised, into pictorial light. Without knowing the event portrayed by this miniature in the high style one can see that the personage being approached in supplication by such a noble group must be exalted indeed: he is even raised higher than his royal visitors within the composition. All the paraphernalia are there (and we are conditioned, as was their first audience, to read miniatures with church eyes) of a homage to a saint. Yet this is a secular image and the man in question is the composer Guillaume de Machaut. He could not perhaps have guessed that his music would be sung and applauded six hundred years later, although even in his lifetime he was celebrated throughout Europe. To be the subject of a whole painting (which though small is as grandly conceived as a mural) is itself an indication of his standing. The image, however, slyly refers to an occurrence so extraordinary that chroniclers mention it with awe.

Machaut (who lived to the then venerable age of seventy-seven) was once visited in his own home by Charles V of France. For a king, albeit a patron of the arts (who owned nearly a thousand illuminated manuscripts such as the one containing this picture), to enter the house of a commoner was virtually unprecedented.

Our visitors here to the great poet/composer are more emblematic. The Queen is Nature and she is accompanied by her offspring Sense, Rhetoric and Music. Her mission is to persuade Machaut to write new songs of love in which he will be assisted by those three Virtues which are in her gift. The painting is full of allusions to the union in art of the natural and the man-made worlds and how one

from *Le Champion des Dames*
(Martin le Franc)
1440, miniature
Bibliothéque Nationale, Paris

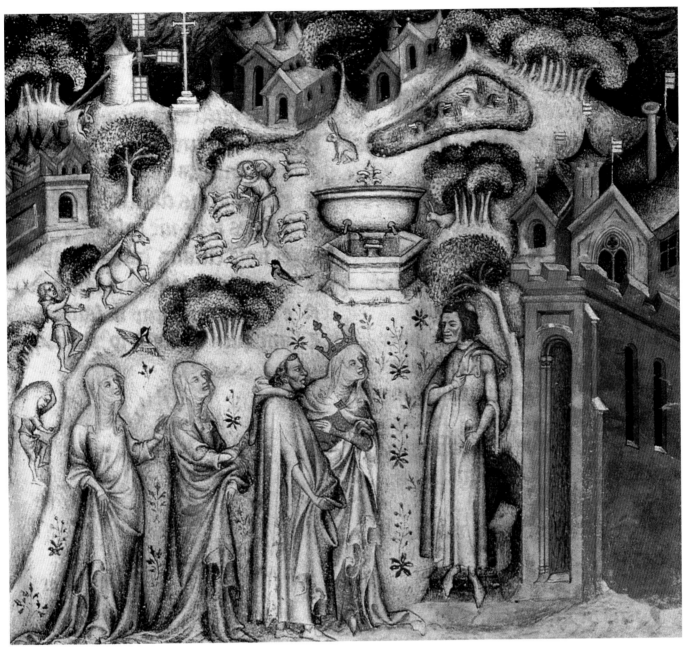

Guillaume de Machaut Visited by Nature, 14th century, miniature. Bibliothèque Nationale, Paris

(as in the windmill) makes the other function for the benefit of humanity. The fountain of inspiration though made by man can only be filled by the grace of Nature. All is combined in an appropriate harmony, urban and rural, wild and domesticated, man and beast in perfect balance within a setting of vegetable abundance.

Amongst the secular books of the following century *Le Champion des Dames* survives in many elaborately illuminated versions in all of which music plays full part. Here a chapter begins with another musical encounter. This less formal

but more historically factual meeting is between two composers whose names are still well known to us. Binchois, who came from the Netherlands was a resident composer at the star-studded Burgundian court, a magnet to the talented artists of the time (including the best illuminators of manuscripts). Binchois is being met (round about 1440) by his exact contemporary Dufay who joined the court bringing musical news from Rome where he had composed for (and sung in) the Papal choir. In an age of easy international communication they would have had no difficulty in conversing since they had

three languages in common. Flemish, French and that esperanto of the time, Latin.

Dufay with his portative organ and Binchois with his harp are vividly portrayed. The bright colours of such pages often surprise those unfamiliar with them. Shut books do not fade: the great frescoes of the Renaissance whose worn beauty we admire were once as bright as these. Here music has the upper hand since it is newly realised each time it is performed and, as with the luminous works of these three composers, is as rich in sound as the day it was written.

75

A Musician Prepares

The trappings and incidentals of musical life provide ritual pleasure. No moment in concertgoing is without some potential delight. Some of us enjoy the mingling in foyers or the crush of an interval drink as much as any of the cultural aspects of an event. Others relish the moment of applause when pent up feelings find their almost orgasmic release with the occasional ejaculations of 'Brava!' or 'Bravo!' There is of course always some premature applauder who will ruin the last note or chord in over-eager ecstasy (or has a need in some little-known piece to show off the fact that he knows when it has ended).

Professional musicians might almost be alarmed to learn how an aficionado savours that strange prelude to a concert when, from a lonely note and plaintive phrase or two, the instrumental sound gathers like a dawn chorus and similarly dies away in a decrescendo of straggling discords and a last perfunctory squawk. For them the business of tuning up is a practical preparation for the evening, yet, for the audience, it is an Overture of Anticipation. Although we may add a counterpoint of chatter before joining in the eventual hush, it has a function for us in that we intuit pitches and timbres and unconsciously gauge the acoustic: in short, we also become attuned.

It is from this chaos that the concert's eventual coherence will be born, and our expectations are heightened just as they are when, invited to dinner, we drink and talk in a room, yet catch the commingled scents from the kitchen of the meal to come, as yet unsorted into particular dishes.

Painters were not slow to depict these informal moments when musicians were seen engaged with their instruments yet not in the full (and difficult to render) act of playing. We are convinced of the relative stillness of someone adjusting a peg to tighten a string, whereas we cannot always believe that the stationary hands in a picture are busy with some brilliant passage in a Paganini Caprice.

That the routine of tuning is eternal can be seen in a painting made almost two thousand years ago in which a group of female musicians are relaxedly getting ready for a concert. Seated upon the raised platform that will be their stage, a woman with a lyre tunes a small harp for another player. Perhaps it is she that has perfect pitch and the rather less confident lady in green relies on her for help. A figure looking on, her head crowned with leaves, may be a singer wondering, as musicians have always done, how it will go tonight. Without such anxieties another rests confidently against a pillar, sure of her part and her performance. Anyone who attends chamber recitals today knows the scene well.

Between this image from Pompeii, removed from a wall in a room where perhaps such music-making took place (giving the picture a doubled quality of anticipation), and Carlo Saraceni's, made in the same country 1,500 years later, lies a whole history of art, in which the idea of a narrative disposition of figures in space was lost and refound. Tuning up, however, continued unchanged and here again one instrumentalist is helped out by another. In this case the lutenist trying to set her strings is no less than St Cecilia, who has put aside her usual attribute, the portative organ (cf. p. 28) in favour of the most beautiful (and paintable) of all instruments. A score and other music-making paraphernalia lie scattered at her feet as if to explain that the angel had not actually flown down with the huge bass viol that he now holds. It is there to show that the foundation of music (in the bass) as well as the inspiration from on high that the angel embodies comes from God alone. As does of course the temperament of pitch itself whose agreements reflect, as he no doubt is telling her, the harmonies of celestial praise. This superbly contrived

Carlo Saraceni
(1585–1620)
*St Cecilia
and the Angel*
1610, oil
on canvas
Galleria Nazionale
d'Arte Antica,
Rome

Preparations for a Concert, Greco-Roman fresco from Stabiae, 1st century AD. Museo Nazionale, Naples

and dynamic composition is the *tour de force* of a twenty-five-year-old artist who was to die only ten years later. One wing echoes the shoulder of the bass viol and the other takes on the outline of the belly of the lute, which itself is placed so that we understand that St Cecilia gives virgin birth to the art of ordered sound. These rounded shapes are set against a long zigzag which extends from the angel's hand on the neck of the viol to the foot of music's patron saint.

For all Saraceni's rococo virtuosity I would in the end rather be in the company of his anonymous Roman forbear, whose fresco (no less artful in its contrast of long languorous curves with a rigid architecture) affords us a glimpse of a fragile, recognisable world of human activity. We shall not see such an intimate scene of music-makers caught unawares again until Watteau's troupe of itinerant performers assembles in the eighteenth century.

Music's Hidden Lessons

We all know this boy and his fate: some of us have been him. Piano lessons represent a leaden phase in many lives, conjuring up a picture as severe and claustrophobic as this. In the ambiguous space behind the luckless pupil sits the tall teacher on a high stool. Time is at a standstill and its very rigidity is emphasised by the presence of a metronome, that dread instrument of correction whose clacking tongue mocks fumbling hands. Even the boy's face is stamped with the metronome's upside-down shape. The only hints of a life of organic freedom are the baroque curlicues on the music stand of that quintessentially French piano, the Pleyel grand, echoed by the wrought iron of what seems to be a balcony leading out into the grey nothing of an awful day. This movement of curves ends in an image of one of the artist's own sculptures whose muted voluptuousness joins the whole picture together: cover it up and the scene is bleak indeed. So the boy must carry on through the endless hour, facing the music under the gaze of the towering metronomic figure of his instructress.

At least this is how in my ignorance I misread the work for many years. In fact the boy is alone and the lady on the stool is a portrait on the wall behind him of a family friend, Mme Raynal, done two years before. Once this dominating presence is thought of as on a flat plane, the rest of the painting starts to unfold and recede into the garden, from which the light streams into the room lighting up the piano lid's surface. It is still a sombre work (which should perhaps be called 'Piano practice') and in a key which Klee would have called Grey major, but, as one begins to read it, the rich harmonies pre-empt the dullness which such huge areas of absent light (the picture is eight feet high) would make inevitable in the hands of a lesser artist.

On the same scale, in the following year, and with his most sumptuous palette in full operation, Matisse takes the same space and subject again and transforms the mood entirely. Whatever intractable scales and arpeggios were being stumbled through before have blossomed into pleasurable music-making. It is easier now to believe that music was Matisse's greatest

love. He himself is present in the picture, in the form of his just used or about-to-be-played violin (like Ingres [cf. p. 96] he was an enthusiastic amateur fiddler). The metronome has vanished and with a visual pun Haydn brings the fresh air and the green of the garden into the room. The nude sculpture has become a pneumatic nymph by the pool. The family is all assembled: Mme Matisse in the garden sewing and the daughter Marguerite sitting with her brother Pierre at the piano (whose lid, still a risky pink, is the only common artistic device of the two works) and Mme Raynal in her portrait is a supple figure dressed in livelier colours.

Matisse called his first great masterpiece *Luxe, Calme et Volupté* after the famous refrain of a Baudelaire poem. There is plenty of *Luxe* in this later work in the almost tropically oppressive foliage outside, and the *Volupté* is provided by the overblown sculpture. But where is the *Calme?*

Once again this is a picture which I at first misread. The figures are not united either in scale or regard for each other. The key to the painting is once again in the bottom left-hand corner where Jean, the older brother of the boy at the piano, sits smoking and reading, isolated in his own dark nimbus and self-absorbed. The picture is in fact a valediction on family life. Jean has received his call-up papers and is about to join the army, and the artist himself is within a year to become more and more cut off from domesticity as he moves from hotel to hotel in the South of France, eventually to become estranged from his daughter and separated at the end from his wife. The truth of the artist's life is to be read more in the earlier canvas, and many painters have both begun and ended their lives in lonely toil.

My failure to grasp the meaning of either of these companion pictures nevertheless led me down fruitful paths of misunderstanding. Such are the joys of changing one's mind amid the welcome ambiguities of art.

Henri Matisse (1869–1954)
The Music Lesson
1917, oil on canvas
The Barnes Foundation,
Pennsylvania

Henri Matisse, *The Piano Lesson*, 1916, oil on canvas. Museum of Modern Art, New York

The Bassoon's Moment of Glory

The world of painting has long welcomed the sound and shape of violin and guitar and admired the sonorous geometries of harpsichord and piano. The robust bassoon, however, in its modern form, hardly gets a look in except as one of a pair of blurred broomsticks distantly seen in a general view of an orchestra. Only once in art has it had a starring role, but in such a distinguished masterpiece that it can claim with Chesterton's Christ-bearing donkey that it truly did have its day.

The mindless close-ups that appear so predictably on cue and are television's answer to concert broadcasting have made us familiar with all the acid or bucolic grimaces that wind instruments call for,

yet here Degas has created a unity of player and instrument as elegant as any of the usual images of cellist or soulful fiddler.

There are of course string players in this work and concertgoers will recognise the types: the soulful, the pedestrian, the keen and the jaded and even the inattentive in the form of (what must be) a violist with an eye for a thigh whose gaze drifts up to the stage.

At first sight, then, this looks like a genre painting in one of the artist's long series of ballet scenes, albeit one in which he has turned the tables on the dancers so that they, in the sawn-off form of a few irradiated tutus and a thicket of lit legs,

provide the background accompaniment to their accompanists. All is not, however, as it seems for this is a portrait and a testament to friendship.

Degas, for all his family wealth and connections, was not a sociable man and had few close friends. Désiré Dihau, who is here portrayed in the full dignity of his profession, was one who saw through the artist's self-protective grumpiness. He and his sister welcomed Degas into their family circle and it was in the sister's apartment that this painting had pride of place from the time it was finished to the day it entered the Louvre as her bequest to the French nation.

Toulouse-Lautrec was also acquainted with Dihau and through him got to meet Degas (thirty years his senior), whom he idolised. It was to this same apartment that one dawn he came with some artist companions after a night-long party to ask if he and his friends might see the pictures by Degas. Somewhat reluctantly Mlle Dihau admitted them and was amazed after a few moments to hear Lautrec ordering the group to kneel down before this particular picture, as an act of veneration.

Homage to Degas took another form when, in an early series of posters, the young Lautrec borrowed the device of a double bass in silhouette, most famously in this design for Jane Avril.

It was not of course to be the last time that this pictorial stratagem was to enliven an image of a band, though never again with the subtlety of Degas, who makes it part of a strange trapezoid in space which gives his small painting depth and rhythm. It is however the first and probably last apotheosis in paint of the orchestral bassoonist for which we bassoonists (if I may, as erstwhile first, and only, bassoon in the Henry Thornton Grammar School orchestra, include myself) are profoundly grateful.

Henri de Toulouse-Lautrec
(1864–1901)
Jane Avril: Jardin de Paris
1893, lithograph
in four colours
Delteil 345

Edgar Degas
(1834–1917)
L'orchestre de l'Opéra
1868–69, oil on canvas
Musée d'Orsay, Paris

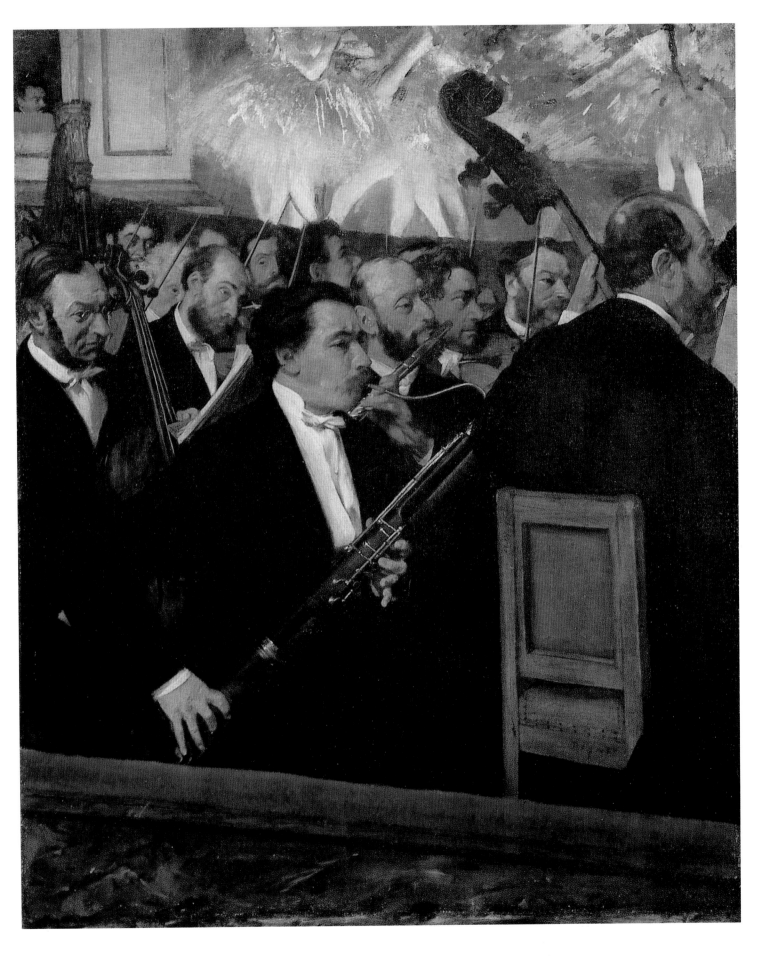

The Anatomy of the Violin

Arman has been cutting up violins for most of his artistic life. With the occasional mutilated piano and dissected cello to his credit, he must be the *bête noire* of any society for the prevention of cruelty to instruments. Needless to say, each of the violins thus anatomised is a poor squeaker bought in a flea-market: no Stradivarius has been sliced nor Guarnerius gutted. The works that come out of this process are full of paradox. The violins now inhabit a graveyard which gives them a second life in art, more successful than their first in music. In their death throes they show how finely they are crafted, how the delicate wafers of wood are kept in curved tension and how tautly drawn is that series of feminine curves evolved over centuries.

These assemblages touched a nerve in the art-buying public (virtually no major museum is without one) and ecstatic reception has led to repetition, in a series of virtuoso variations. The artist is caught in a celebrity trap with a market for more and more filleted fiddles. He has recently taken to making bronze casts which can be editioned, thereby undermining his own apparent message. At one remove from the

elegantly cut wood these works now lack his surgical iconoclasm, for we know that, reassembled, the instruments would be dumb metal reproductions: the nerve has gone out of the enterprise.

The title of this group of violins with a cello dangerously incorporates the concept of coffee table with its hint that what was once an avant-garde art of gesture has now entered the world of millionaire's plaything.

The best lesson in aesthetics I ever received was from the American composer Morton Feldman, who said that the most important distinction to be made in creative life was that between a notion and an idea. A notion leads to the narrowing path of formula whereas an idea opens up a broadening avenue of research and exploration. To illustrate the thesis in this context one has only to turn (once again) to the finest painter and maker of still-lifes in the history of art, Picasso, who performed so many variations on the theme of deconstructed instruments, especially (as here) during the short years of Cubism.

Picasso was notoriously unmusical and seems to have had no interest in the

compositions by Stravinsky, Satie, et al. that gave rise to his marvellous theatre designs. One of his mistresses said that the only thing he knew about bars was how to get from one to another; yet musicians and their instruments continually recur in his work. In this study his empathy with not only the look but the presence and feel of a violin is complete, even in the funny obliquity of the fingerboard. Here dissection plays a two-part invention with its reflection in the repeated scroll and mirrored sheet of music. The reference to wood is mostly transposed to the surround where the artist uses a trick learned from Braque of simulating wood grain. This framework of realism allows him to improvise with all the evocative and recumbently erotic forms of the violin itself. The title *Jolie Eva* is a covert reference, posing as a song title, to Eva Gouel, one of the numerous *Ma jolies* of his life. This world of analysis joined to personal passion is a far cry from the coffee table. Picasso embraces his subject and coaxes out more of its inner secrets than any sampling of cross-sections could show us. Picasso sees what Arman has to saw.

Arman (b. 1928)
Coffee Table with Violins and Cello
1987, bronze and glass
Marisa del Re Gallery, New York

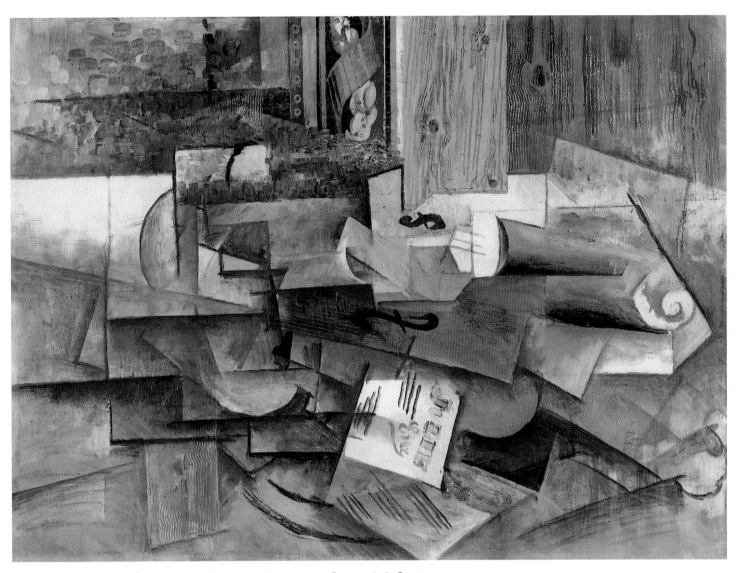

Pablo Picasso (1881–1973), *Violin: 'Jolie Eva'*, 1912, oil on canvas. Staatsgalerie Stuttgart

The Body Language of Inspiration

It is one thing to identify a musician by means of the paraphernalia of his activity (instrument, large busy scores, etc.) but quite another to represent the purest of all acts of music, the mental labour of composition. This is the task of those who try to portray the composer 'at work'. What, at a glance, differentiates the ruminative pursuit of composing from merely worrying about one's tax returns? Nothing of course, and it can be reasonably supposed that the composer, while undergoing the torture of being painted as the imaginer of transcendent sound, is in fact pondering where the next bit of cash is coming from (Wagner) or what cigars to order (Sibelius) or what horses to back (Elgar).

The solution is somehow to bodyforth the moment of inspiration. A slight upward gaze often serves to indicate the yearning for this gift from heaven (whence cometh neither financial wisdom, cigar advice nor tips for the 3.30). All is in fact a convention, for a composer might well get his ideas in the bath or be visited by the

muse while mowing the lawn, or tying up a shoelace. None of these would be acceptable to a public that is only convinced of the natural in the presence of extremest artifice.

The beginning of such a convention can be seen in the earliest representation we know of a non-mythical composer. The tenth-century manuscript illumination of Notker Balbulus solves this problem by association. The author and composer of sacred chants is shown in a position, and with attributes (a book, desk, etc.) traditionally associated with an Evangelist. This bold move immediately links his pensive state with divine guidance. The contemplative head with its faraway gaze rests on the hand, a trope of description still in active use: few films featuring real or fictitious composers would omit it (usually to be followed by a dash to the piano to play an 'immortal theme').

Such an idealised suggestion is resorted to by Ingres in his two portraits of Luigi Cherubini, one of his favourite composers.

Ingres, a passionate music-lover and (notorious) amateur violinist was flattered by the friendship of one who had met both Haydn and Mozart and had been admired by Beethoven. Contradictory evidence and anecdotes surround the paintings. A drawing exists of the eighty-year-old composer naked to the waist (the kind of preparatory study for a clothed figure which dates back to Raphael) indicating Ingres's painstaking approach. This seems at odds with the contemporary accounts of Ingres painting the portrait from his drawing of the face only and asking another composer (Gounod, no less) to sit for the body and hands. If the latter is true, this is a unique double portrait in musical history. It was, however, common for an assistant to stand in for various bits, other than the head, of a distinguished sitter.

In the first portrait (identical in pose), Cherubini, apart from the presence of a quill pen near the corner of a score, could be (as in this drawing) mistaken, with his dry, unyielding features, for an elderly

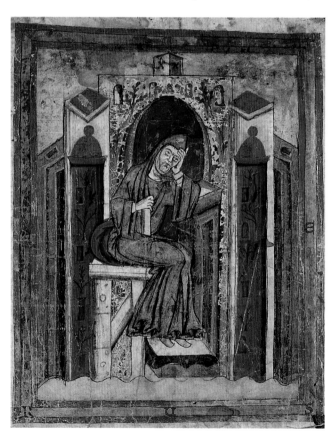

Anonymous, *Notker Balbulus*, 9–10th century, vellum. Staatsarchiv Zürich

Jean-Auguste-Dominique Ingres (1780–1867), *Study for a Portrait of Cherubini*, 1835, drawing. CNSM, Paris

Jean-Auguste-
Dominique Ingres
*Luigi Cherubini
and the Lyric Muse*
1842, oil on canvas
Louvre, Paris

bank manager in a small and dingy office. The entry of a huge muse bearing the seven-stringed lyre of Orpheus provides, as well as a heavy hint that musical composition is afoot, a lightening of the picture's grim tonality giving it a larger space to breathe in. The little three-note melody in red that is played from left to right of the canvas relieves the gloom on the face of a composer, who, although famous in his day and head of the Paris Conservatoire, had been passed over by his compatriot Napoleon when the big commissions were given out.

The introduction (without consultation) of divine inspiration into the life of a working musician annoyed Cherubini when he set eyes on the picture. A short period of coldness between the two men was set to right by the composer with a song in honour of 'Ingres, worthy of love, the resplendent painter' (to quote the words of its first line). It was to be his last work; he died in the same year.

The heavy but wonderfully hovering hand of the muse symbolises not only the secularisation of imagery itself but that of its audience. Now, after countless chairmen and petty politicians have adopted the traditional pose of Balbulus, artistic devaluation has lost it any link with the Evangelists and their heavenly visitation of thought.

Music without Instruments

The business of conducting happens in thin air with no visible means of making a noise except a little stick (and not always even that). It takes a very good artist to show that the person in question is neither merely waving nor is an affluent man being held up by bank robbers.

The extraordinary picture of Sir Thomas Beecham painted by W.R. Sickert in 1938 almost makes light of the problem, capturing all the imperiousness of Beecham's character and his musical authority in a single sound-summoning gesture. Even the plain-looking background (in fact an evocative abstraction of Indian red and umber worthy of Rothko) seems to hint at an endless opera house of dim-lit plush, an ingenious 'essence of theatre'. This, together with a flow of light softly rising to meet the contrast of evening dress, suggests indeed that Beecham is conducting in the pit of the Royal Opera House, of which, at the time, he was virtual dictator.

One might expect sculpture, occupying as it does a physical space, to give a yet greater sense of volume and immediacy. For all that David Wynne's version of the subject some twenty years later is both literal and inventive (including a cast of a real baton) the strange compromises of modern bronze portraiture leave us with an uneasy trio of amputated elements which agitate rather than command the air around them. One sees an action but can imagine no sound.

Sickert's canvas is flat, yet full of resonating atmosphere. We almost hear the full, rich satisfying chord which is the correlative of the harmony of colours. As a pure act of painting the portrait carries premonitions of much that would follow in art a generation or two later. As often in the great final phase of his work Sickert takes up an impoverished source, probably a newspaper photograph (as yet unidentified: art historians would be grateful to any reader that might know its origins) and, harking forward to Andy Warhol, turns it into an icon. Such sketchy source material is often the most useful for an artist since it offers the most scope for imaginative extension. The handling of oil paint, especially in the head, which, close up, looks like an incoherent set of blobs within a simplified outline, prefigures the world of Bacon and Kitaj.

I was lucky enough to sing (albeit as a member of a large chorus) under Beecham at one of his last concerts. Having always loved this painting I was delighted to see Sir Thomas corroborate Sickert's image as he adopted this same expansive pose to usher in the opening of Handel's *Messiah*.

Art, like conducting, is an alchemy. Despite his professionalism and skill Wynne's sculpture remains earthbound, unable to transcend its technical encumbrances. Sickert, from the base matter of a newspaper clipping, which would, in that era, have consisted only of a sequence of coarse dots, conjures up a true presence just as Beecham himself that evening transmuted other dots on paper into the gold of living sound.

David Wynne
(b. 1926)
Sir Thomas Beecham
1957, bronze
National Portrait
Gallery, London

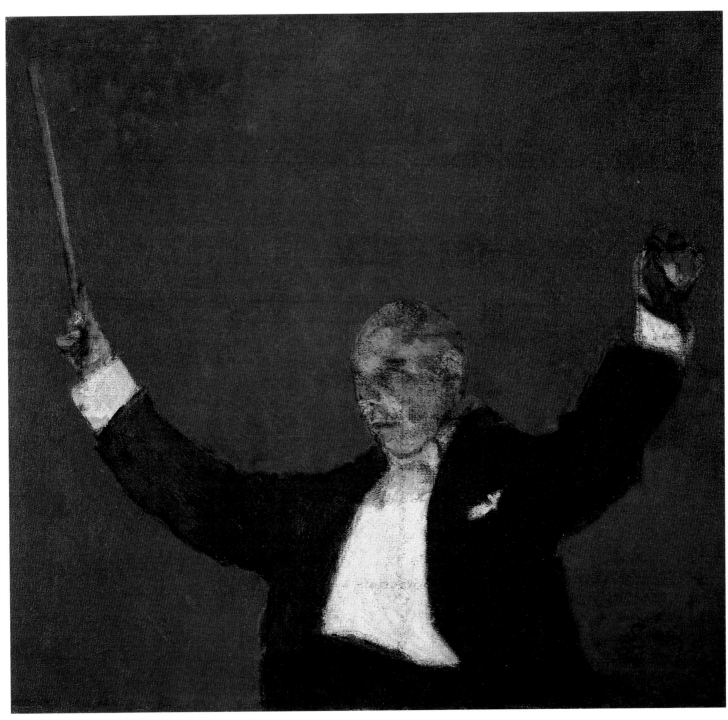

Walter Richard Sickert (1860–1942), *Sir Thomas Beecham Conducting*, 1938, oil on burlap. Museum of Modern Art, New York

Two Kinds of Realism

Trompe l'œil has a long history: virtually all we know of the great painters of classical Greece is that their pictures deceived the sight, so that birds tried to peck at the painted fruit on painted dishes and horses reared up before depicted monsters. Fortunately the glowing late embers of antiquity that survive (like the 'House of Mysteries' murals in Pompeii) reassure us that there must have been more to the works of Zeuxis and Apelles than that. *Trompe l'œil* after all merely does what it says, it tricks the eye, effecting a kind of brain bypass. It is an art done for the lazy by the industrious. Its principal paradox is that a genre of

art that seems somehow to be scientific turns out to be sentimental.

Paradoxical too is the discovery that what looks highly professional and academic reveals itself in the end to be a branch of folk art. It was America that led the field in the nineteenth century and William M. Harnett was its toiler-in-chief. His letter racks and pinboards with their bent and peeping playing cards are favourites in those museums still not too snooty to hang them.

Still Life: Violin and Music is a fine example and its contents have a typically American homespun narrative quality. The artist found himself running a race

with photography which in his lifetime was presenting another pseudo-reality (did people, though, really think the world was brown, flat and rather small?). This violin with its unspoken story is a true still life in that it shows life stilled, distanced from the ambiguities of experience. It is not a violin trying to be a painting but a painting trying to be a violin. As a consequence it moves out of the serious arena of art, where the violin had slowly replaced the lute as a favoured still-life subject whose form combines in lines and curves the masculine with the feminine and whose presence gives the mute pictorial world a latency of sound.

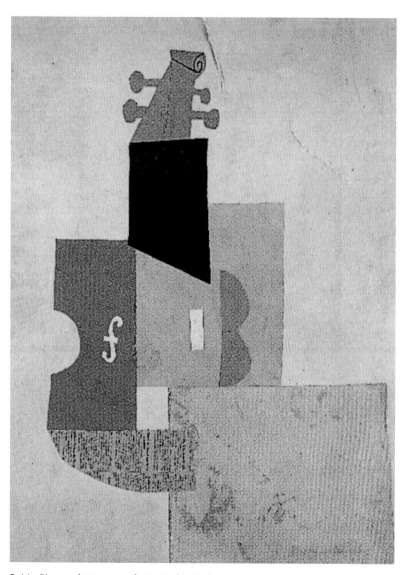

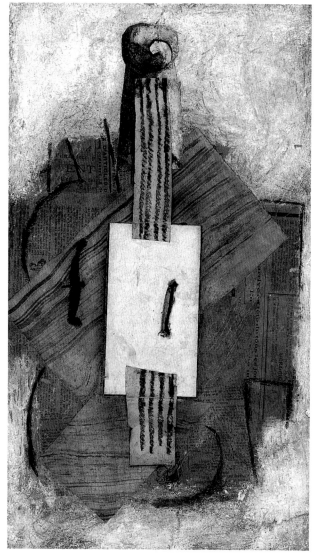

Pablo Picasso (1881–1973), *Violin (Violon)*, 1912, collage. Picasso Museum, Paris

Pablo Picasso, *Violin (Violon)*, 1913–14, collage. Picasso Museum, Paris

Such aspects are better seen in two of Picasso's many variations on the subject, where we see that he is not only the greater virtuoso but is in fact the more stringent and literal realist. His ingredients are the same, yet he physically cuts the f-hole in one picture and actually lays the strings over the body of the instrument in another. He refers to the essence of the violin as a box (the word often used for the fiddle by professionals today). Picasso's printed page is real, forming its own witty commentary on the idea of *trompe l'œil* itself (in other pictures of instruments he uses scraps of actual sheet music).

For all the carefully rendered rust and dust, the naive strategies of Harnett's picture lead it away from reality as it dawns on the viewer that each of the elements is there only to cast a shadow or catch the light. What storytelling quality they have is secondary to their role in the game of deception. Nothing in fact joins up. The piccolo will never play with the violin, and the sheet of music provided features neither instrument. It was precisely this mad, dysfunctional quality that Surrealists like Dalí eagerly borrowed for their hallucinatory encounters of lobsters and telephones.

Trompe l'œil (hardly a match, after all, for Virtual Reality) is now a seldom visited byway of art, and, like certain cosy overtures that have been dropped from the concert repertoire, its absence creates a gap in the world of innocent pleasures. One misses its earthbound charm and teasing pathos as well as the proof it gives that art has quite other jobs to do.

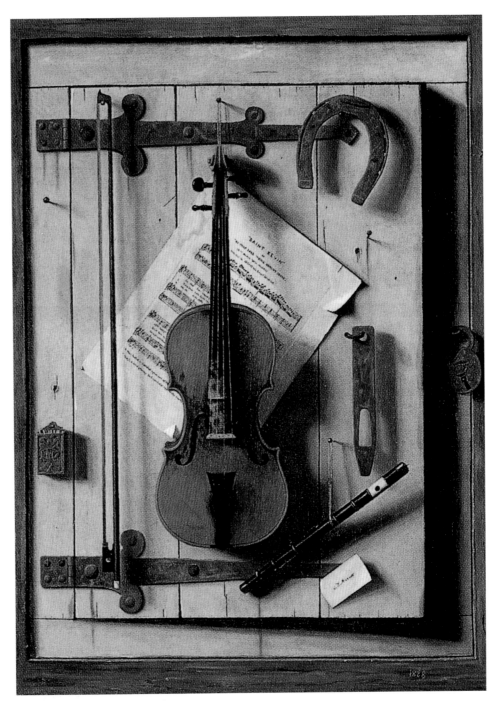

William M. Harnett (1848–92), *Still Life: Violin and Music,* 1888, oil on canvas. Metropolitan Museum of Art, New York

Music to Soothe or Seduce

The association of the violin with the devil does not hold true of its ancestors in the string family, which have a long history as participants in art's angelic orchestra. One member of the section here has just flown down, complete with instrument and sheet music, to play for the Holy Family as they rest on their flight into Egypt.

The story told in Matthew's Gospel, of the refugee family travelling by night to avoid detection by the spies of Herod after the decree that all new-born children be slaughtered, is a favourite subject for painters. An alien landscape of crepuscular mystery, in which lonely exiles snatch a moment of respite on an arduous journey, is a theme that has lost none of its human relevance. On any night before or since (including tonight) such a group might be found huddled amongst their pathetic bundles.

In this variation on the theme the whole scene is transformed by the metaphor of music and its eternal paradox: a noise that brings quiet to the soul. Caravaggio, still in his very early twenties, a delinquent precursor of Genet, has here turned away from his customary images of violence and homoerotic innuendo for a moment

to acknowledge a larger world of human sympathy. Music, previously featured in his work as a mode of seduction, plays the role of visitation of grace. It soothes (via a characteristically witty reference to Orpheus) the whole hierarchy of God, woman, man and beast.

The painting is, perhaps, an aubade rather than a nocturne, as the landscape, for all its miserable aspects of sharp stones to tear bare feet, knotted undergrowth and broken trees, is suddenly glorified in a new dawn light. Mary and the Child sleep on, while Joseph holds the music as if in a compact with the angel to comfort the exhausted mother. It is Joseph, after all, in Matthew's story who has seen the angel in a warning dream and will receive from the same angel the news of Herod's death. Caravaggio's well-known practice of painting everything from life (so tellingly captured in Derek Jarman's excellent film in which a modern artist lovingly evokes his soulmate's gypsy court of four hundred years ago) has given the weary Joseph exactly the right position, with legs supporting tired arms, that anyone who has ever held up music for another will know.

Caravaggio's very literalness, the solidity of his stones and water bottles and the position of the old man's torn feet, one resting in its pain on the other, raises all kinds of questions. Why doesn't an angel, of all beings, know his apparently straightforward melodies by heart? But then a hardened musician might impiously reflect that only an angel among string players would be content with an audience of four, only two of whom are awake and one of *them* an ass.

Though the rational spirit might think this the most extraordinary solo recital ever given, all scepticism vanishes in face of the atmosphere and harmony of the work to whose tender, second emblem the eye keeps returning: that calm right hand of the Virgin, correlative of the music being played and speaking so eloquently of safe repose. Darkness closes in after this. Landscape is banished for ever from Caravaggio's work and the musicians move indoors as can be seen in the more typical interior here, making this miraculous moment in both the Nativity story and in the artist's vision, unique.

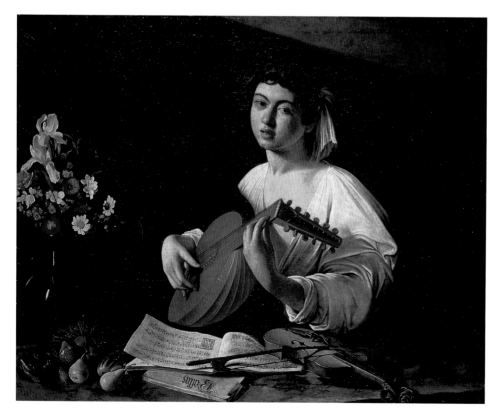

Michelangelo Merisi
da Caravaggio
(1571–1610)
Lute Player
c.1595–96, oil on canvas
Hermitage, St. Petersburg

Michelangelo Merisi da Caravaggio, *Rest on the Flight into Egypt*, c.1596–97, oil on canvas. Palazzo Doria Pamphili, Rome

Graphics of Degeneracy

Art, like music, has its dangerous uses. The language of each can be bent to serve evil while retaining its glamour. Even if, in the world of fine art, the pioneer spirits may not always be bought, their discoveries can be assimilated by designers less fussy in the masters they serve.

Such was the skilful Lothar Heinemann, who here fashions a Nazi icon to endorse the aesthetic of the Third Reich in the seemingly innocent mode of patriotic piety.

The potency of the image comes from its invocation of the very things it does not mention: Bach and the Church. Any depiction of organ pipes in a Teutonic context must tacitly bring these two together and here they accept the embrace of the heraldry of National Socialism: the two great spiritual forces are literally brought under its wing. Even the text has a propagandist edge, hinting at another land; one, in the well worn phrase, without music.

By compacting such rich associative imagery in a simple captioned format, Heinemann did his job brilliantly. Wagner's 'Holy German art', the free anarchic and individualist world of music, has been reduced to a regimented phalanx of organ pipes standing to attention. They serve as the plumage and talons of the emblematic eagle whose wing-feathers manage to suggest the curtains of an opera house. The whole structure addresses its audience in the architectural rhetoric of Fascism, which had already been seen with similar lighting effects in Leni Riefenstahl's defining film of the Nuremberg Rally. The art of the cinema is present here in the cunning montage.

Meanwhile, behind this pictorial boastfulness, the progressive movements in art were already being stifled. Hitler made a mocking visit to the exhibition of Degenerate Art (Entartete Kunst) in 1937 and a year later a show of 'Entartete Musik' was arranged. Hindemith's opera *Mathis der Maler* was denounced and the composer fled the country. Heinemann's poster of 1935 had been the writing on the wall. There is however a moral gulf which separates the defining of a political correctness from the abuse and persecution of its dissenters. No such dignity of alibi that Heinemann might claim could be pretended to by 'Lucky' whose poster-cover for the *Entartete Musik* brochure contains no mitigating ambiguities.

The off-centre composition and clashing colour scheme are the antithesis of Heinemann's symmetry. The saxophone represents the lowest rung of the instrumental ladder, an over-sinuous Belgian invention used exclusively by aliens. Its player, also too sinuous to be wholesome, is a portmanteau parody of the non-Aryan, a simian caricature of a Negro made more absurd by an evening dress which sports what seems to be a carnation. This turns out to incorporate the Star of David. To

Ludwig Tersch ('Lucky'), *Entartete Musik*, 1938, poster-cover. Paul Hindemith Institute, Frankfurt/Main

compound the degradation (which omits only homosexuality from the anti-canonical inventory) the black Jew wears a gypsy earring. The American-style graphic idiom is, of course, meant to convey all the unhealthy formlessness of Jazz.

It is typical of ideological states that it is an appeal to the lofty (as in the Stalinist genre of Socialist Realism) that spells the debasement of their art. Cultural cleansing is always a story of babies and bathwater.

At that same time in England, the Land without Music (where the arts are not taken seriously and a sense of the silly somehow protects against totalitarianism), a seaside picture postcard by the inimitable Donald McGill (1875–1962) appeared which also incorporated Bach and the Church. A nervous couple of holidaymakers are passing a churchyard whose notice-board advertises a recital: 'Bach's Organ Works', it proclaims. 'So does mine', says the would-be lover to the blushing girl at his side.

Lothar Heinemann
*Deutschland,
das Land der Musik*
c.1935, poster
SMPK, Berlin

The Mind's Construction

Everyone knows what a genius looks like. We have built up a canonical group of those that bear the clear lineaments of intellectual labour and spiritual quest – Dante for literature, Leonardo for art, Beethoven for music, Einstein for science. A montage of their faces would furnish an identikit image whereby we could spot their successors. A parallel list, however, could be drawn up with names of equal weight (Schubert, Rembrandt, Socrates, etc.) who, ranging in looks from the plain to the unprepossessing, would not attract attention in a bus queue. Shakespeare (another case in point whose blankness of look has helped many to think that someone else wrote his plays) summed up the dilemma in Duncan's words before the approach of Macbeth: 'there's no art/ to find the mind's construction in the face'.

The physiognomic fallacy was finally put to rest in a recently exhibited work of art by Christian Boltanski in which many pairs of photographs are brought together of murderers and their victims (without identifying which were which). The impossibility of distinguishing slayer from slain was a chilling experience. There was, however, a time in the eighteenth century when Lavater, a Swiss scholar, persuaded people (in three almost unliftable volumes) that the study of physiognomy was on the edge of being an exact science and that faces told their owners' whole story. Had he examined, with his graphs and taxonomies and tabulations, two of the composers who lived in his lifetime, Bach (who would have to be classed with innumerable pedestrian burghers) and Mozart, he might well have abandoned his enterprise.

Mozart's small stature and inconsequential features were often remarked on by his contemporaries. The images that have come down to us (he was after all especially well documented in his infancy and youth) give us, in their stiffness, no encouragement to imagine him otherwise. Who knows whether, had he been more impressive of bearing and more identifiably brilliant of expression, he might have had a better share of worldly success and have escaped being kicked around (in one case literally) by forgotten prelates and courtiers now obscure. Baudelaire describes the artist as one who always feels like a prince travelling incognito: the Mozarts of the world whose faces betray no special gift or power have to make

Saverio dalla Rosa (1745–1821), *Wolfgang Amadeus Mozart*, 1770, oil on canvas. Mozart Museum, Salzburg

their journeys through the world under a double incognito.

The painting by Saverio dalla Rosa of the fourteen-year-old virtuoso is, in its routine iconography, a typical musical portrait of the time. Mozart stares out at us with a pale pinched look: he has ceased to be an infant prodigy and is now an uninteresting-looking teenager wanting to be taken seriously. In regulation attire ready for years of court servitude he poses awkwardly at a keyboard. There is no intimation that these fingers could dance over the keys to the amazement still of all who heard him. Dull though the picture is it features a unique coup for the painter. The page of music so dutifully copied by the artist is indeed part of a piece by Mozart otherwise unknown and unpublished. Köchel, the composer's indefatigable cataloguer whose inventory gives us the identifying K number we find on every score and CD, allotted it a special designation as K 72a.

A decade later the family portrait by Johann Nepomuk della Croce of Mozart with his beloved sister Anna Maria ('Nannerl') and their father Leopold is a crabbed affair. Leopold is a mere cardboard cutout occupying a non-existent space. Nannerl, perched on a chair that seems to drift away from her, sports a coiffure that must have taken longer

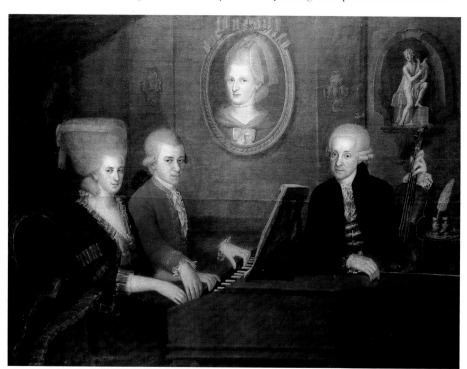

Johann Nepomuk della Croce (1735–1819), *The Mozart Family Portrait*, 1780–81, oil on canvas. Mozart Museum, Salzburg

Joseph Lange
(1751–1831)
Wolfgang Amadeus
Mozart at the Piano
1789, oil on canvas
Mozart Museum, Salzburg

to arrange than her brother would have needed to write a sonata. He himself looks glum and cornered: his right hand, hanging like a dead fish, would not have marked him out for a musical career. Dominating the composition at its centre looms a seemingly gigantic portrait of their mother (who had died two years before, in 1778) by Degle. The mismanaged perspective makes her head and shoulders about one and a half metres high. This is pictorial awkwardness rather than psychological insight, though the result to the modern eye is a nightmarish claustrophobia of family dysfunction. Only on closer inspection does one see that the painter tried (and failed through incompetence) to make his sitters smile.

Luckily the visual dice are not all loaded against Mozart. In his engaging memoirs Michael Kelly, the Irish tenor who sang in the first performance of *The Marriage of Figaro*, describes the composer ('the little fellow') as inconspicuous but adds that, when aroused by music his 'bright eyes and face' lit up in a way 'as impossible to describe as it would be to paint sunbeams'. Few portraitists can capture such transient joy. Handel gave the artist the same problem. Images of Beethoven (not without his collusion) invariably contribute to the myth of eternal, beetle-browed concentration, even though contemporaries made special mention of his fine teeth displayed in a broad smile.

That other Mozart who shadows his own sunniest music to give it a tragic undertow appears to us in painting only once, at the very end of his life. By some magic of chance Nannerl's husband's brother, Joseph Lange, was an artist. Not a great artist, but one who with a family sympathy and a more intimate knowledge than any other, leaves us a portrait of a Mozart we can believe in. The nondescript features suddenly betray spiritual depth. The fragmentary nature of this unfinished canvas gives us a secondary emblem of the doomed composer. Lange reaches that grail of portraiture, full empathy with his sitter, which eludes his colleagues. Our own emotional investment in the painting makes it a masterpiece. Perhaps (and perhaps fortunately) he was not quite aware of the historical responsibility of his task or that, had he painted all the crowned heads of Europe, he would not be remembered as he was to be for this touching icon of music's dying prince.

The Devil's Best Tunes

The loftily classical Ingres and the romantically sensual Delacroix seemed as far apart as ice and fire to the art lovers of early nineteenth-century Paris. Each had his ardent following and only the sturdiest spirit might rise above the hostile factions and admit to admiring them both. Time changed all that of course and eventually their roads converged in the work of Picasso and Matisse.

That their apparent incompatibility was only skin deep is shown by their remarkably similar tastes in music. Ironically each found his sensibility perfectly mirrored in the beauties of Mozart. They were also united in their admiration of the legendary virtuoso Niccolò Paganini and both of them attended, albeit in different parts of the house, his famous concerts at the Opéra.

It is perhaps from a memory of one such occasion that Delacroix pictures him playing: a flickering presence barely emerging from theatrical gloom. This is the received image of Paganini, who in the popular imagination of the time was thought to be in league with the devil (who has a long folk history as fiddler on the hoof). The gaunt and pallid musician, seen here in 1831, his fiftieth year, did nothing to discourage such profitable rumours. Like the late Sviatoslav Richter he would only play with the stage lighting reduced to the merest glimmer.

Delacroix's tenebrous version seems at first a far cry from the clarity of the Ingres study made in Rome some dozen years before, but there is just as much fluency and swagger in the brilliantly drawn coat with its hint of unkemptness to come. The challenging stare and the guarded instrument add up to an image of power momentarily held in check. Whatever this commanding man is going to do, it will be done with conviction and dazzling expertise.

Ingres's devotion to Paganini's art was, however, not unquestioning. On one occasion when the virtuoso, as was his habit, treated a packed house to a series of violinistic novelties and tricks (farmyard impressions, etc.), the painter rose in his box and shouted, 'This is betrayal! Betrayal of genius!'

In Delacroix's painting one half-catches the sound of some mercurial passagework from one of Paganini's tortuous Caprices, while in the Ingres drawing one sees the bright energy and solid self-possession that made such virtuosity possible.

Did Paganini play for Ingres that day in Rome, or, more fancifully, did the artist, himself a keen amateur violinist, ask to try the Stradivarius he had just drawn with such economy and ease?

Jean-August-Dominique Ingres
(1780–1867)
Paganini
1819, line drawing
Cabinet des Dessins, Louvre, Paris

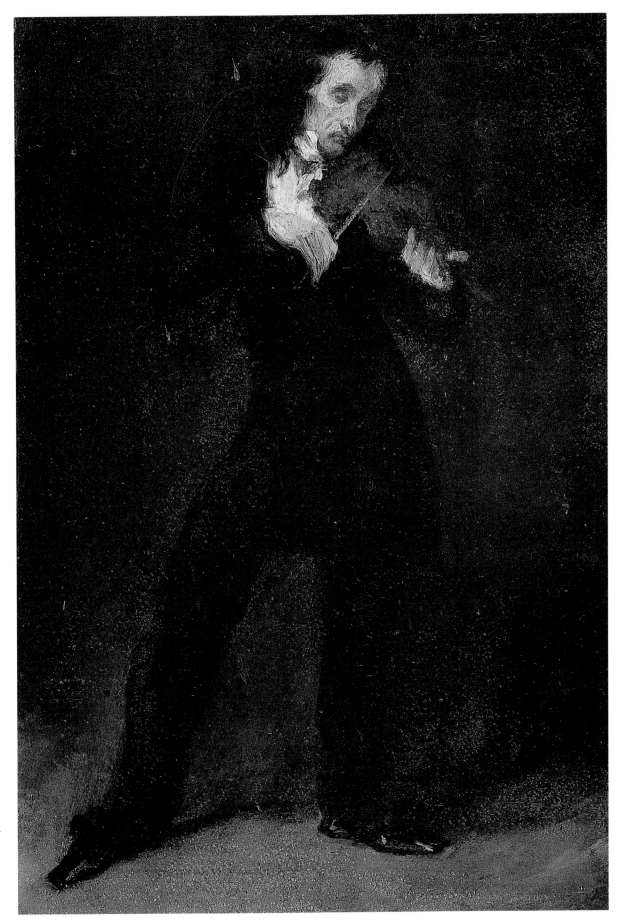

Eugène Delacroix
(1798–1863)
Paganini
1831, oil on
cardboard
The Phillips
Collection,
Washington, DC

One More String to His Bow

These pictures are relics of uncompleted enterprise. They are from the instantly recognisable hand of a man whose endless invention condemned him to make thousands of pages of notes and drawings for projects no human lifespan could allow him hope to accomplish. Treatises were started on wind and trees, on water and anatomy, on optics and fortification: studies for countless pictures and sculptures exist, few brought to fruition and most unbegun.

Here was the intellectual equivalent of Midas. In every area of human enquiry his brain visited it encountered golden ideas to be sketched or written up in his mirror writing. None of them saw the light of day in his lifetime. Only a few years ago, yet another large notebook was discovered in Madrid which showed us, among other wonders, the unsuspected depth and detail of his mechanical researches. The codices or grand sketchbooks in Windsor and Milan, however, show a less-known aspect of his endeavours.

As a young man at the court of Milan, Leonardo was already celebrated for his musical virtuosity. Vasari reports that 'he sang divinely, improvising his own accompaniment'. He was best known as an inspired player of the lira da braccio, an ancestor of the violin. Not only was his performance envied, but also the tone and elegance of the instrument itself on which he played (for he had of course designed and made his own), whose body was a horse's head modelled in silver. As a composer he was in the aristocratic improvisatory tradition and committed no melodies to paper except for a few bars as here, scattered through his notebooks, containing cryptic messages in their tonal sequence.

The theory of musical sounds, their harmony and temperament and the problems of acoustics formed the subject of another treatise, but it was the mechanics of music-making that produced the best of his drawings. Even as director of armaments to the Sforza court he devised automatic mobile repeating drums to head the troops into battle (and save on soldiers).

Many of his projects and schemes have since been constructed and tested. Not all were strictly practicable with the technology of the fifteenth century. His drawings, however, always seduce: the fine, nervous, left-handed sketches with their calligraphic annotations could give equal beauty to a study for a parachute or a wind-cowl on a chimney (both of which he seems to have invented) as to an equestrian monument. His key-system for a flute anticipates that of Boehm, three hundred and fifty years later.

The instrument described here (and in other detailed studies) is a unified string orchestra of almost perpetual motion. The 'viola organista', like a transcendental hurdy-gurdy, has many strings in contact with a complex system of wheels that act as bows of infinite length.

Almost a curiosity among his small output as a painter is an uncharacteristically simple portrait of a musician. Some scholars think it may represent the pupil whom Leonardo taught to play the lira da braccio, but it more probably portrays the artist's musical mentor, the composer and theorist Gaffurius, who is known to have helped Leonardo with his musical studies. For all its unaffected directness and its inevitable unfinished state (reminding one of a line in his notebooks, 'Tell me, tell me if *anything* was ever done') the head is brilliantly resolved as a solid by means of the artist's patent *sfumato* or 'smoky' shading.

Not to be confused with Leonardo da Vinci himself is the eminent eighteenth-century Neapolitan composer Leonardo Vinci. His music still features in concerts and the name, when it crops up in a programme, gives one a start. He was the epitome of skilled competence and in no way resembled that strange being, cursed with universal gifts, who painted the world's most famous portrait. It is not totally surprising to learn that Mona Lisa, while she sat for the picture, was diverted by the musicians the artist had hired to keep the celebrated smile of sombre delight on that most famous face.

Leonardo da Vinci
(1452–1519)
Study of a Mechanical Violin
pen and ink on paper
Biblioteca Ambrosiana,
Milan

Leonardo da Vinci
Two Musical Phrases
The Royal Collection,
Windsor

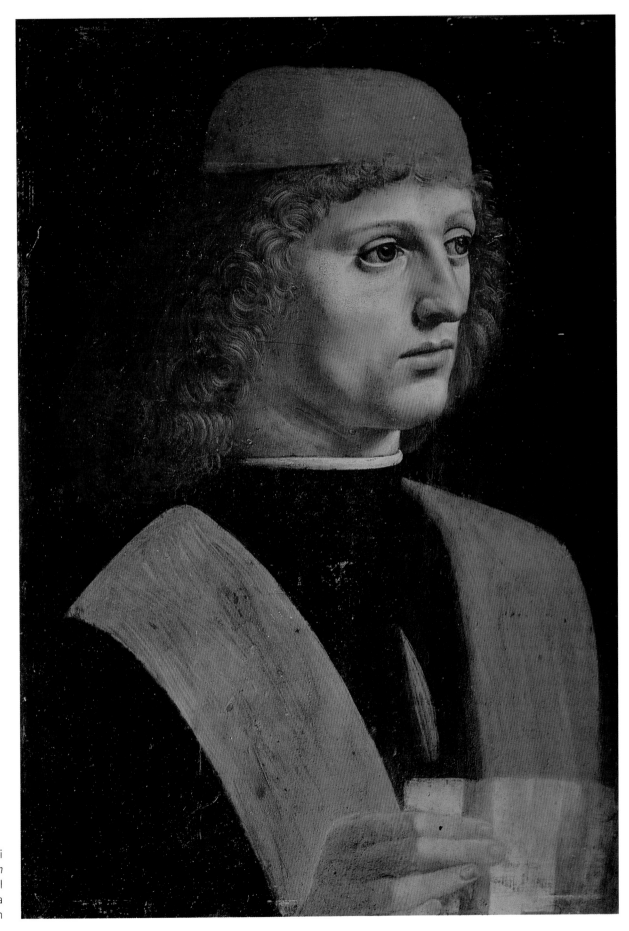

Leonardo da Vinci
Portrait of a musician
oil on panel
Biblioteca
Ambrosiana, Milan

Music from Another Room

Every artistic career has its ups and downs. Reputations fluctuate both in a creative lifetime and after death. A few decades of neglect can be rewarded by an eternity of fame just as the seeming certainties of present celebrity can be briskly extinguished. Bach, now so securely seated on Parnassus, was regarded as of merely academic interest until Mendelssohn in the nineteenth century dragged his music out of the study into the concert hall.

History, with infallible good taste, usually sorts things out, but in Vermeer's case took a very long time to do so. His more or less complete obscurity lasted for over two hundred years. Those thousands who queued for hours to pack the Mauritshuis in The Hague and gaze on his assembled work would not, a century before, have known his name.

Only when a connoisseur called Thoré-Bürger singled him out from the legions of minor Dutch artists did he start (as Johannes van de Meer) to have any identity at all. In the seventeenth century, when Dutch artists could make (and, in Rembrandt's case, lose) fortunes, he scarcely emerged from the shadows. While painting his tiny and slowly achieved output of masterpieces, he made his living as a dealer in the pictures of those he would eventually eclipse.

He is the great master of private life. Once we are familiar with his domestic world we know his house and its every room. Music mutedly haunts his work, even when its source is absent. While a woman weighs pearls or reads a letter we imagine the half-heard chords from a guitar or the arpeggios of a keyboard from an adjoining chamber. When we are actually in a room where an instrument is being played the sound is scarcely louder. Somehow the months of silence that have gone into these paintings still inhabit them, as does all the precious light that ever poured through small windows in a northern town.

The *Young Woman Seated at a Virginal* has long been seated in that sunlight and now gives it back. She is made of circles and parts of circles whose continuations spiral through the canvas: yet they cannot get out of hand since the stern geometry of keyboard and picture frame tempers softness with severity. The angles of bow and chair back, lid and curtain, have all been worked out with mathematical rigour. No painting whose atmosphere is so calmly human can ever have had such rigid scaffolding. Thoré-Bürger was rewarded for his quasi-discovery of Vermeer by being able to purchase this picture in 1867 for 2,000 francs (about £80).

The massive viola da gamba in the foreground gives a curved musical anchor to the composition and hints at sounds yet to be heard. With delicate wit Vermeer places another rounded instrument to balance it in the opposite corner, where in a shadowy painting of a tavern scene (*The Procuress* by van Baburen, which, since it occurs in another picture, was probably part of Vermeer's stock) a lute is being strummed. Little in Dutch art of this period appears by accident: objects in either interior or still life have a moral purpose. Here our musician is poised between love untried (the silent viola da gamba) and the flesh indulged (Baburen's bawdy scene).

Strangely enough a large proportion of the paintings by Vermeer that deal overtly with music (including Kenwood's *Lady with Guitar*) have conspired to gather together in London. Next to this picture in the National Gallery hangs a companion piece in which the same virginals have been moved to the lighter side of the room. In

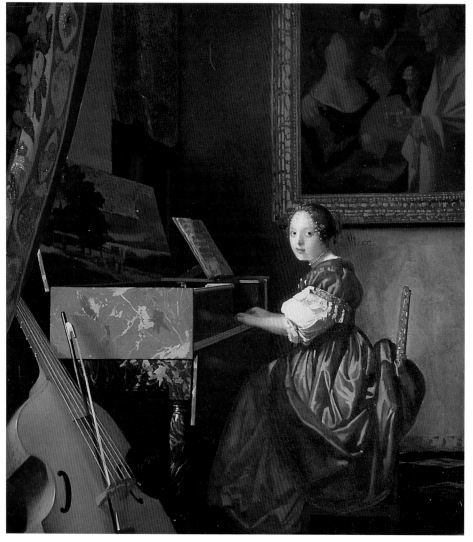

Jan Vermeer (1632–1675), *A Young Woman Seated at a Virginal*, c.1670, oil on canvas. National Gallery, London

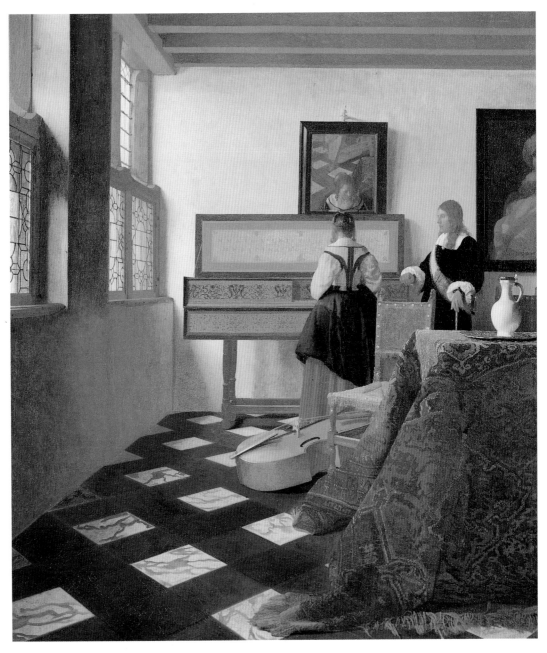

Jan Vermeer
Music Lesson
(A Lady at a Virginal
with a Gentleman)
c.1671, oil on canvas
The Royal Collection,
Windsor

the Queen's Gallery at Buckingham Palace, only a few hundred yards away sometimes hangs a wider view of that room featuring different virginals but the identical viola da gamba. It is one of the most enigmatic interiors ever painted.

The subject of the music lesson in Dutch and French painting is invariably an alibi for some blatant or cryptic sexual encounter. The music teacher, so essential for instruction in a requisite female accomplishment, infiltrates a household with the ease of a priest and has unrivalled opportunities of intimacy with its young wife and younger daughters (a situation whose perils are a stock in trade of opera). No such goings-on in Vermeer, however.

Once again, the geometry and grid of the image are as strict as a Mondrian, dismissing all thought of dalliance. If there is any erotic charge in the painting it is in its very aloofness.

The only hint of engagement in the two very separate figures is the demure inclination of the girl's head reflected in the mirror (where part of the artist's easel reminds us of an unseen third presence). Voluptuousness is also at one remove in echoes of the girl's narrowly waisted torso in the vase on the table and the picture hanging on the right. This is high restraint but the profit is in the density of the atmosphere (in both senses) and the hymn to hoarded light.

We know, at least in this picture, the maker of the virginals by name. Andreas Ruckers was one of a dynasty of Antwerp harpsichord makers so distinguished that their members (along with luminaries like Jan Breugel and Rubens) were excused service in the civic guard. A Ruckers instrument ordered from Antwerp was considered a Steinway-like luxury in its day. One is led to suspect (especially if two virginals were owned at the same time) that tales of Vermeer's modest circumstances are exaggerated. But with Vermeer all is conjecture except our knowledge of what it was like, palpably and unforgettably, to be, three hundred years ago in Delft, in that best painted of all houses.

Apotheosis of the Concert Grand

Of all the objects of western civilisation a grand piano is one of the most evocative: it can on its own furnish a room. It can dominate and inform a space both by virtue of its massive displacement of air and the world of associations it brings with it. It is the coffin of the sounds it has made and the box of delights from which marvellous music may spring when its lids are raised in awakening. It has in its stance an earthbound masculine aspect and in its recumbency a feminine curve: it is ready (to continue the unfashionable metaphor) to command or submit. The camera loves it and circles round it waiting to pounce when the player's fingers in some brilliant piece of passagework become a hectic blur. Even unplayed, or played as here from underneath, it is the standard prop of the musical portrait. Cage adored and abused the grand piano in many ways, primarily by preparing its inside with insertions of rubber, sticks and coins between the strings (a loving foreplay that itself took hours) to make it into a complete percussion ensemble. But the piano never lost its dignity and would always return to its evening-dress look, a huge black abstraction. The piano has starred in many films. Who can forget the disembodied hand playing an arrangement of the Bach

*Flowered piano c.*1903–05 postcard

Chaconne in *The Beast with Five Fingers* (Ervin Nyiregyházi on the soundtrack) or the crack of James Mason's riding crop across Ann Todd's fingers in *The Seventh Veil* or the drop of blood falling on the white keys that spells doom for Cornel Wilde's Chopin in *A Song to Remember?* Needless to say there's never an upright in sight, the screen being gracefully filled with the angles and swellings of a gleaming grand.

The act of sitting down at the keyboard in a concert hall has no match for theatricality in all the instrumental realm. It had to be for the piano that John Cage (again) wrote the notorious *4'33"*: only thus was the heightened anticipation of sound created in a piece that, consisting as it does only of silence for that duration, turns out to be a virtuoso composition for unaccompanied audience.

Perhaps it was a knowing extension of that piece into infinity that provided the starting point for Joseph Beuys who evokes an even more thunderous silence with his felt-clad piano. The teutonically pedantic title is hard to unravel, though the 'homogeneous infiltration' could be interpreted to mean that the felts within the piano which serve to mute the sound are now extended to envelop it and subdue it into permanent silence. With Beuys it does not pay to ask too many circumstantial questions but to yield to the artistic gesture. The use of felt together with the cross is an autobiographical reference. After a plane crash in the war he was revived by his rescuers by being covered with felt and plastered with lard. The device occurs again and again in his work, sometimes, like Shostakovich's musical signature, to the point of irritation: here somehow it seems particular, for one senses the contrast of the French-polished object beneath a matt austerity whose greyness mixes the black and white of the

Playing John Cage at the Warsaw Festival in 1975. Photo WF Archive

keys. Pianos of course are often covered when in store or when the owners of grand houses are wintering somewhere luxurious. But these are temporary: a twitch of the corner can reveal again the hidden beast. Beuys's shroud is otherwise, admitting no re-entry. The paradox is that the wrapped piano, now itself an object of culture, is an emblem of the suppression of culture. Deprived of glory the instrument is also protected from error, yet the unmistakable form retains those resonances and associations listed earlier. Beuys's own life history haunts the object: is it a piano killed in action or one rescued and preserved?

An innocent pre-echo of this covered piano where Jeff Koons seems to meet Joseph Beuys and Liberace (long before any of them were born) is found in a postcard c.1903. Although so delicately clad in flowers the massiveness of a grand still announces itself, now made more the heavyweight of the keyboard world by being seen in such flimsy disguise. Although only an illustrative curiosity the card does suggest the presence of an idea waiting for its final artistic realisation.

No triviality evoked the sublime more than a photograph I remember in the Bayreuth shrine-cum-museum Wahnfried of an American serviceman who had thrown back the covers and was jabbing with one finger (while grinning at the camera) the keys of Liszt's piano amongst the rubble of Wagner's house. What Siegfried of the keyboard might have the licence to reanimate Beuys's sleeping giant?

This imposing work asks such good questions that speculation can spiral from it without end into zones of pretentiousness as rarefied as anyone could want. But look again. The object itself is simple, grave and reticent. The artist's probity is the guarantee that within that caul of felt is a real grand piano and not a dummy. If it were anything else we would be duped and all irony would fall away, for here is a piece in which soundless art, always envious of music, speaks of its very denial of sound and makes of dumbness a stupendous eloquence.

Joseph Beuys (1921–86)
Homogeneous Infiltration for Grand Piano
1966, piano wrapped in felt
Museum of Modern Art,
Pompidou Centre, Paris

Playing in Difficult Times

In these two images of Russian composers in their forties, each eloquent in its different way. Shostakovich is immediately recognisable as the one with the worst hairdresser in musical history. There can have been few portraits more spartan than this, with its minimum permissible relief in the form of a child's drawing (by the then nine-year-old Maxim who himself was destined to become a distinguished musician). I am not sure whether Piotr Williams is saying. as an ethical prescription. 'This is how we must live' or 'This is how Dmitri Shostakovich lives'. In either case it is a perfect example of Soviet realism: painting as a moral exemplar. Realism in art. in any combination of terms. is always suspect and usually means an orthodoxy of fiction (the 'real' being far too chaotic and sprawly for art truly to represent it).

Images of Shostakovich invariably show the same archetypal mid-school swot (he could as easily in this picture be 17 as 41) getting older and more embittered as the revolution he had so enthusiastically identified himself with was betrayed under its own banner. Unlike Stravinsky. who became an international figure early in life and abandoned Russia to its fate. Shostakovich stayed at home and saw it through.

Prokofiev took the middle course. leaving for long enough to establish his credentials elsewhere. returning in his fifties with his wife and two sons. The atmosphere in this little study is almost emblematically contrasted with the Shostakovich portrait. Prokofiev is in mid-exile but playing paradoxically on Russian soil. The cosmopolitan composer is completely at home in the lush interior of the Soviet embassy in Berlin. So indeed is the painter Leonid Pasternak (father of the novelist) as the intimist chronicler of a vanishing artistic society existing in Chekhovian comfort. Its radical members were soon. like his own son Boris. to be forced underground or to be silent or to meet unspeakable fates. Nothing could have been more irrelevant to the new Russia than Leonid Pasternak's Vuillard-like charm. His formidable gifts can be seen in the perfect economy of this evocation of plush and gilding. You know what slightly muffled tone the piano would produce. even how a footfall would sound. If an ideological gloss had to be given then one would suspect the painter of giving Prokofiev a halo: in a Cold War novel. on the other hand. the two relaxed figures in evening dress would be purposively watching musician or painter. or both.

In looking at home-grown Russian art of this century. dates are (as almost nowhere else in art history) crucial. almost to within the month. Prokofiev is living in Paris at the time of this picture: he will return to Russia in the year that Shostakovich's portrait was painted. Each composer was optimistic in 1947. Prokofiev hoped, with *Peter and the Wolf* and the music to Eisenstein's *Alexander Nevsky*. to have even the Soviet version of the motherland clutch him to her heart. Shostakovich had himself accepted the humiliations that visited him in the Thirties. While Prokofiev was playing in the lavish embassy. he was completing his capitulation to the modified version of the Revolutionary aesthetic with his Fifth Symphony ('A Soviet artist's reply to just criticism').

Each of them was in for a shock. Prokofiev's international acclaim was no protection against the accusation of formalism and. under the same rubric. Shostakovich lost his professorship. The arch-apparatchik Zhdanov could identify ideological backsliding in a string trio or lack of support for the Five-Year Plan in a flute sonata.

The nasty thing from Stalin's point of view was that music is dangerously abstract. Painting and the visual arts could just be wiped out if they erred on the side of abstraction. as indeed they were after the brief moment of creative euphoria under Lenin. Once 'realism' was the

Leonid Pasternak
(1862–1945)
Prokofiev at the Soviet Embassy, Berlin
1937, oil on canvas
Glinka Museum, Moscow

norm. subject-matter could be dictated. But music was a slippery customer whose sinister agendas had to be identified. The 'Song of the Stakhanovite' or the 'Hymn to the Tractor' is seldom heard in the Russian concert hall today. Their medal-laden authors have vanished into thin air. Virtually no creditable painting survives from the Soviet period: there are no heroes in the visual arts who underwent Shostakovich's mental torture and managed to carry on blurting out some of the truth. With painting castrated and literature muzzled, music alone held a torch which all the winds of mendacity and ignorance could not quite blow out.

Piotr Williams (1902–1947)
Portrait of Shostakovich
1947, oil on canvas
Glinka Museum, Moscow

Practise Makes Perfect

Every picture is a performance of some kind, but, just as in musical life, practice and rehearsal form the daily substance of an artist's activity. Some great paintings, like those of Cézanne and Giacometti, contain their entire rehearsal history, being conflations of all the errors and approximations that have gone into their reading of the subject. The more normal ambition of course is for art to conceal art, and there are bravura painters like Rubens who seem to have conceived, and executed, the most ambitious pieces in one go. We envy them; until we find the many trial sketches from life or more worked-up colour studies which, like sight-reading and dress rehearsals, preceded the final apparently effortless product.

Here are two English paintings of professional cellists in the act of playing. They appear to epitomise in every respect the difference between diligent application and spontaneous brilliance. But all is not as it seems, for both were patiently and painfully arrived at over a matter of years rather than weeks.

Augustus John's flamboyant picture of Madame Suggia aptly figured in a Tate Gallery exhibition (1993) called 'The Swagger Portrait'. It is a virtuoso performance full of broad brush strokes as confident as the sweep of the musician's arm. John looks to have heaped the rich colours as he has piled up his drapery, in a burst of creative frenzy, yet, underneath these fine certainties lie a multitude of adjustments and revisions. The picture in fact took three years to produce and Mme Suggia had to be cajoled into more and more extra sittings as the artist lost the energy of the human action in new orchestrations of colour, or reclaimed the drawing only to muddy the harmonies that were so much part of the painting's imperative. We know, from the sitter's own account, of the wild shifts of mood that gripped the painter (as she herself worked steadily through the Bach suites again and again, a more esoteric part of a cellist's repertoire in the early Twenties than they are now). When things had gone well John would boom out fragments of the melodies and dance around the studio, but often the sessions ended with the painter in despair. When finished it was a huge success. After its first showing commissions flooded in from clients expecting to end up as triumphantly present and vibrantly alive as la Suggia. John was never quite to equal it, however, in the long decline of his later career. Worse still he had set a trap for himself with this dazzling and apparently fluent canvas. It turned him into a society portrait painter, an immensely profitable business from which artists have always found it hard to escape.

Sixty years later Patrick Symons made no attempt to hide the tortuous hours of effort that went into his touching portrayal of Jennifer Ward Clarke. This is the other side of the coin both musically and artistically, and just as appropriate an analogue of its subject. Rather than sitting back to admire a performance at full projection we are drawn into a world of study. Jennifer Ward Clarke is a well-known interpreter of contemporary music and can easily be imagined here working on the fine detail of some daunting score while Symons matches her concentration with his own intensity, touch by delicate touch. The artist himself was a robust amateur cellist and one can sense the listening ear as well as the analytical eye. Symons was that greatest of rarities, an egoless painter, and he leaves us alone in the room with the musician at work, a room which, with its telling details, we can explore at leisure. The cellist too, dressed for practice (no one plays scales in golden shoes with four-inch heels), loses her ego to her art and to the picture whose title merely names her activity.

For all their striking differences each of these paintings is a unity fully achieved and each has its apposite structure: John's portrait is built around the huge diagonals of the canvas whereas Symons (as keen a geometer as he was a cellist) uses a complex series of rhyming angles to hold the image in a geometric web. Each is at one with its subject as these two fine interpreters are seen to be at one with the music they play.

Patrick Symons (1925–93)
Cellist Practising
1969–71, oil on canvas
Browse & Darby, London

Augustus John (1878–1961), *Madame Suggia*, 1920–23, oil on canvas. Tate Gallery, London

The Instruments of Joy

Professional violinists often refer to their instruments as a 'box'. They thereby reduce it to its true essence as a shell of wood acting as a resonator. No matter what strings you buy or polish you use, if the hollow body itself lacks quality, you are wasting your time. The legendary craftsmen of Cremona provided the standard. The long-evolved shape, acoustically and ergonomically perfect, had poetry enough, especially when realised in woods of handsome grain.

Paradoxically, these works of Shaker-like simplicity by the Amati and their followers were made precisely when the language of art was at its most tortuously elaborate. The musician and inventor Michele Todini epitomises the splendid excesses of the Baroque. A notice in New York's Metropolitan Museum of Art, announcing the sober prospect of viewing the Crosby Brown Collection of Musical Instruments, leaves one unprepared for the dazzling sight of Todini's harpsichord, a sculpture whose gilded extravagance rivals the exuberant fountains of his native Rome.

Michele Todini
(c.1625–c.1689)
Harpsichord
c.1675,
gilded wood
Metropolitan
Museum of Art,
New York

Unknown artist
from Guinea-Bissau
Guitar
oil can, wood and wire
Livesey Museum, London

The instrument, covered in scenes of marine mythology, seems just to have been raised from the sea by Tritons. Beneath it a naked pair of nymphs wander like two Rhinemaidens looking for a third. As if this were not enough, a giant seashell surmounted by a cherubic figure and powered by dolphins heads in their direction. Already, this seems way in excess of musical requirements, yet our illustration fails to show the gigantic flanking statues of Galatea and Polyphemus. The latter gives the game away: the set of bagpipes that he holds can be controlled from the keyboard. What we are in fact looking at is the precursor of that currently most fashionable form of art, the installation.

Contemporary engravings show entire rooms of Todini's museum of musical instruments (the first ever) and its maker would sit at a keyboard while, to the

amazement of the (paying) visitors, a ghostly orchestra would be summoned up by hidden mechanisms as unmanned harps and distant painted organs sprang into action.

Unlike many makers of eccentric automata, Todini was also a visual perfectionist, and there is wit as well as extravagance in his design. With its finely judged proportions and the enlarged mir-roring of the harpsichord's shape in the sculpted sea, the whole ensemble would be worthy of the Metropolitan as a pure and silent example of the high Baroque.

As well as such formal epics, art too has its jazz, where ornament can play an insouciant variation on the theme of the box, as here in a guitar from Guinea-Bissau. In this more rugged world, the chance encounter of an oil can, a piece of driftwood and some purloined telegraph wire can, in half an hour or so, become a guitar. The oil can is shown here raw, and cooked after yielding to the ornamental itch. There may be a difference of years rather than hours in how long these instruments took to make, yet the colourful spontaneity of the one promises the same joys of sound as the elaborate artistry of the other. Like Haydn, who always dressed up to compose, they have put their best clothes on for music.

Todini's Museum
from Athanasius Kircher
Phonurgia nova
1673, book illustration

Venus and Her Musicians

Great art and music happen when intellectual and sensual imaginings meet in a unified field. Good painting and good composition may be achieved by the very clever, but only those through whom run all the currents and juices of full human life can reach greatness. The merely brilliant dry up in mid-career and repeat themselves. The Beethovens and Titians are driven on by the heart's imperatives to ever braver late inventions. Legend (promotionally assisted by the artist himself) used to have it that Titian continued to paint up to his hundredth year. Certainly, like Picasso, he was still at his easel in his ninetieth (cf. pp. 24, 25). Thus the famous series of works involving a naked woman with a musician (plus an occasional cupid and guest appearances by frisky little dogs) belongs, though painted in his fifties and sixties, to his middle period.

Neither the bony clothes-hangers of modern-day fashion nor the pneumatic bimbos of tabloid soft pornography have any place in the grown-up world of Venetian sensuality. Ripeness was the anatomical all, an ideal that a woman might attain before twenty and sustain through childbearing into middle age.

It is here expressed as a symphony of soft convexities. This woman is not the object of the musician's desires but its subject, and, by implication, the subject-matter of his music. Titian's sophisticated clientele at once saw how the theme brought together the arts of painting, music and narrative as well as uniting the genres of

landscape and urban interior. He himself evidently found pleasure and profit in exploring the possible variations. In this Berlin version the emotional situation is shared with the light itself which glows in the mounds and valleys of nature in both its forms while an urgent cloud seems to travel from the left as an erotic emblem

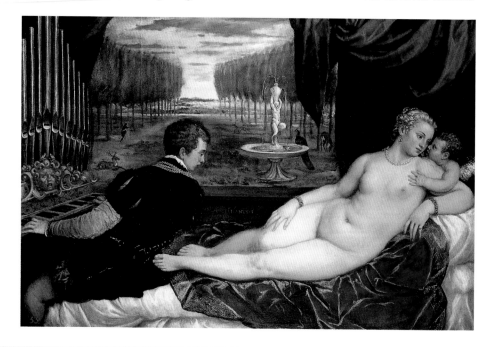

Titian
*Venus and
the Organ Player*
c. 1548, oil on canvas
Prado Museum, Madrid

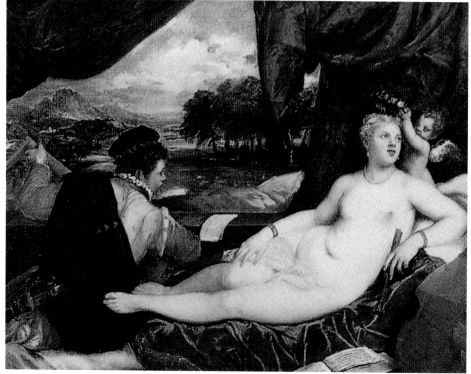

Titian (c. 1485–1576)
Reclining Woman with Lute Player
c. 1550, oil on canvas
Fitzwilliam Museum, Cambridge

Titian, *Reclining Woman with Organist,* c.1550, oil on canvas. SMPK, Berlin

of the impassioned musician. His frank gaze encompasses all her beauty. The fine variant in the Prado, however, is more overtly sexual. The organist now stretches closer and stares unequivocally towards her genital region. Meanwhile in the background a priapic fountain spurts forth and a pair of lovers is seen embracing. Titian's visual wit is expressed by the continuation of the organ pipes into a line of trees emphasising the unity of music and nature.

The canvas from the Fitzwilliam Museum belongs to the later group in which a lute-player takes over from the organist and draws nearer to the woman. Her abstracted expression is less engaged, though her possession of an instrument indicates complicity. In the landscape, however, they are united, as the clouds echo her breasts and thighs and the trees repeat the shape of his shoulder. The different geometry of the lute allows Titian to make (with the assistance of some extra drapery) a magnificent parallelogram, a repeating cage from which this moment of desire can never escape since the viewing eye is urged back into the image from either side.

What are these paintings *about*? While scholars pick at their iconography, e.g. the significance of the dogs and the possible identification of the woman with Venus, the audience is in no real doubt or difficulty. Their meaning rushes straight at the viewer: they are simply about love and its expression, about music and its primacy as the vehicle of love, and about the forms corporeal and incorporeal that embody and inspire it. We sense without analysis for example that in the Berlin picture the cupid is enacting the lover's thought, defining the woman's form with his arm and approaching her breast with his hand. A man and a woman would of course look at the painting in different ways, yet so mature, generous and unexploitative is Titian that both are fulfilled.

It is in the very spirit of music that the artist (a keen listener and player) improvises these variations with varying contributions from the workers in his studio. As soon as his own magic hand is absent, however, as in the chilly version at the Metropolitan Museum of Art, New York (evidently a late, even posthumous studio production) the sexual excitement disappears, leaving cold meat for art historians rather than warm flesh for lovers.

The Psychopathology of Instruments

Sleeping, we are all artists. The slippery logic and shifting metaphors of our cinema of dreams became the primary source material for the Surrealists. As directors of our nocturnal movies we know all the devices of verisimilitude that make the outrages of Surrealist painting so plausible. It was no accident that Hitchcock, when he had to insert a nightmare sequence into *Spellbound* (1945), called on the services of Salvador Dalí to provide the imagery.

It is the Surrealist's job to describe the improbable in the language of credibility. Dalí's mastery of Old Master techniques allows him the maximum latitude. What the six images of Lenin are actually doing, rising like symbolic gas jets from the keyboard of a grand piano, we can never know, any more than we can identify the enigmatic object seen through the open door, or put a name to the strange frail figure with his curtain-like cloak and mysterious armband. On the chair next to him sits a still-life of cherries on a cloth. More recognisable as a musical hallucination is the parade of ants beginning to colonise the blank score on the music stand: every player knows the terror of turning a page to find a sudden multitude of notes swarming all over the following sheet. We may fight to attach

meaning to this or that part of the picture. We may think that we ought to know the answer to questions like why Lenin, why cherries, etc., in order to appreciate it. Yet the work has an overall authenticity, its own lucidity that makes these problems finally fall away as the dream replies. 'Why not?'

Music on its own cannot produce Surrealism: all its sounds really happen and describe themselves: it is defeated by its own reality. Painting is a far more tricky affair. It can make allusions to what cannot be and can do so with a straight face, as we can see in the visual puns and paradoxes of Magritte. His compendium of uneasy juxtapositions in which trains emerge from fireplaces and a man confronts his own back view in a mirror is presented in as deadpan a fashion as Buster Keaton's gags in a silent film.

Nothing could be further away from Dalí's dazzling virtuosity than Magritte's deliberately pedestrian style. Their ways of life were equally contrasted. Dalí, the extrovert Spaniard with his notorious upturned moustache was a legendary eccentric who courted the limelight, whereas Magritte, the phlegmatic Belgian, carried on an archetypically bourgeois existence and kept office hours.

Aficionados and players of the tuba, however, owe their allegiance to Magritte, who featured the instrument in his art both as a soloist in his famous painting of a tuba on fire and as a central feature of such disturbing and incongruous ensembles as his trio which goes under the title *Le temps menaçant* (Threatening Weather). Once again no explanation will rationalise the presence under that rubric of a cane chair, a nude female torso and a tuba, but we are in no doubt (how could such a stolid image lie?) as to the utter inevitability of their presence.

The great age of Surrealism was not to last long (these pictures were painted within a couple of years of each other) and perhaps its end was heralded by the London International Congress of Surrealists, in 1936, at which Dalí memorably (and almost fatally) attempted to give a lecture from inside a deep-sea diver's suit. The icons of the two great practitioners have well outlasted some of the puerilities of the movement and still can cause the proper frisson of disquiet. They have given us waking dreams we cannot forget, and after seeing the work of Dalí, the lyric poet of the genre, and Magritte, its prose master, neither grand piano nor tuba can ever look quite as innocent again.

René Magritte
(1898–1967)
Le temps menaçant
1929, oil on canvas
Scottish National Gallery
of Modern Art, Edinburgh

Salvador Dalí (1904–89), *Composition/Evocation of Lenin,* 1931, oil on canvas. Museum of Modern Art, Pompidou Centre, Paris

Music *en famille*

Artists in the past were often just as itinerant and careerist as their musical counterparts. Philippe Mercier was a Europainter extraordinaire. Born in Berlin the son of Huguenot tapestry-makers, he went to study in France before spending the obligatory period in Italy. He then decided to head for England where, with a non-stop demand for portraiture, an artist's fortune could be made. This turned out a good move for a sophisticated, continentally trained professional: by the age of forty, he had become Principal Painter to the Prince of Wales (a now vacant office). All went smoothly for a decade or so until a court quarrel forced him into obscure exile in York. There he set about painting his way back into favour with London society through pictures in the vein of this music-making family.

All seems natural here as the intimate family group works through a piece, perhaps by Handel, whose portrait Mercier had painted (cf. p. 54). They play from a single score, the mother peering anxiously at the flute part while behind her (with the sharper sight of youth) the younger daughter sweeps across the strings of her violin with a confident bow held in the style of the time. The more eligibly aged daughter looks out at us as her graceful hands move along the keyboard without apparent problem. The grandmother meanwhile stoically gets on with the job of her supporting part: she seems used to the fact that the cello, always busy with giving the music its bass foundation, never gets the tune. Thanks to her spectacles she can still take part in the newest pieces and indeed the picture is from a time when novelty was at a premium and (a far cry from our own era) only 'modern' music was played, even in the domestic repertoire.

This would also have been true a hundred years later when Zoffany (another German-born artist who made a successful career in London) painted this more artificial-looking pyramid of musical people. Piled high in what appears to be the poop of a barge they have a distinctly unusual group of instruments at their disposal. Since there are not enough of these to go round one guesses that they are taking turns at playing and that the relative who has arrived with his serpent will eventually have his moment, as will all present except perhaps the infant, the cat and the dog. A choice bit of England sleeps across the calm river behind them. The real virtuoso of the event is Zoffany, the constructor of the artifice in which music seems to be the alibi for a dazzling display of fabric painting, from sheen of oriental silk through flickering lace to the light-swallowing subfusc of clerical attire. Mercier, one senses, is always painting with ambitious labour at the edge of his abilities. Zoffany is a far more gifted artist

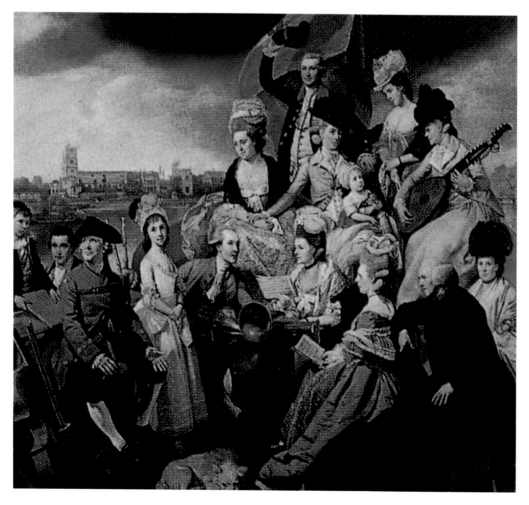

Johann Zoffany (c. 1734–1810)
The Sharp Family:
A Musical Party on the Thames
1780, oil on canvas
National Portrait Gallery, London
(on loan from a private collection)

who can take risks and, as here, bring off an unlikely triumph out of near absurdity.

The paradox of the two paintings is that the improbable Sharps are a true family unified through the activities of making and listening to music, real people in real relationships to one another. The 'naturalistic' quartet, however, in the Mercier picture do not know each other, have probably never even met, and in the case of the younger girl (modelled from an older painting) may never even have existed at all. It is in fact an allegory, part of a series that the artist painted in what Horace Walpole called 'the genteel style'. Such 'fancy pictures', as they were known,

were all the rage and this domestic fiction belongs to a set called The Five Senses (Hearing, Touch, Taste, Sight, Smell). So slight is the allegory and so undemanding the metaphor that this could represent Sight or Touch as easily as it does its actual subject, Hearing. The harpsichord-playing 'daughter' is supposed to be our intermediary, listening to the others and drawing us into the act of hearing. Such pictures are in essence poor relations of Watteau's subtle *Fêtes galantes*, whose mystery is hinted at in the ambiguous background. Mercier is no Watteau yet he does give us, via his silvery harmonies and the expertly unified articulation of the

Philippe Mercier (1689–1760)
The Five Senses: The Sense of Hearing
c.1750, oil on canvas
Roy Miles Gallery, London

figures (making a clever rhombus in space of arms and instruments), some intuition of a vivacious consonance.

With this series (and others based on the Seasons and the Times of Day) Mercier returned to London. Mezzotint versions of such pictures sold at about 50p a set and the group of paintings of the Senses found a buyer at the not too modest price of over £100. Mercier had calculated the market and timed his comeback to perfection.

The Rest is Silence

Braque was a bit vague about titles. The catalogue names of his pictures came from dealers rather than artist. Here the puzzle is a musical one. Although the painting's title usually appears as *Mandolin with Score*, it was called *Banjo* when it was first reproduced and written about: hence its hybrid designation in the recent Royal Academy exhibition in London. The confusion vanishes when one recalls the hazy history of this versatile instrument. Often known as the 'bandolin,' it was frequently referred to, in a folk context, as 'banjolin'. Braque, an excellent musician, who could strum adeptly on any fretted instrument, probably (in his fondness for rural music) knew it by this name: certainly this particular example with its large and cheerfully braided cord would be more at home in café than concert hall.

Braque devoted the largest part of his career to the discipline of the still-life. This speciality is art's equivalent of a contemplative order where human nuisance can be avoided. Apples, unlike models, are always on time, bottles seldom move and a skull no longer requires a mid-session cup of coffee. There are, however, no alibis for the painter, for there is no one to blame. The lineage of French masters of this testing genre descends from Chardin in the eighteenth century via Cézanne in the nineteenth to Braque in the twentieth.

Such was Chardin's focus on his traditional arrangements of everyday items, prosaic knives and fruit and pots and pans, that he became within his mind a Lilliputian tourist of table tops. He wandered around a landscape of huge events, climbing up the side of a knife-handle to see an orange loom ahead, glowing like the setting sun. Cézanne evidently had the same experience where a folded napkin suddenly assumes the weight and mass of his beloved local mountain, Ste Victoire.

If Cézanne was the ascetic of the vocation (he even preferred paper flowers to their live equivalents, whose unpredictable behaviour upset him) then Chardin was its philosopher. Calling this work *The Attributes of Music* he referred to a wider world of association than a mere inventory of the tools of the musician's trade. Rhythm, sonority, interval, harmony, are all alive in a dynamic range from the muted turquoise of the music stand to the clear accented whites of the gathered papers. Reading the picture like a score from left to right (as is the eye's habit) the action is announced, after a tiny high monotone provided by a bow's end, by the abrupt red edge of a book like a bright horn call breaking from a dark harmony of strings. This is echoed at the other end by the clear white note of a candle rising before the work drifts back

into that special silence which is the medium in which all still-life operates.

Painted for a space above a doorway, the picture is organised to be seen from below. Chardin welcomes both the demand for virtuosity and the scope for his sense of play, as in the teased-out sheets of music which simultaneously hang over and curl away from the viewer. The rounded frame (as well as the fragmented and faceted grouping of planes and curves) links it to the still-lifes Braque was to paint a hundred and fifty years later when the problem of eventless corners led to the adoption by the Cubists of an oval format.

Braque was the lyric poet of the still-life's meditative brotherhood. It was he that introduced the themes of musician and musical instrument into the Cubist repertoire. Picasso, though notoriously (even boastfully) unmusical, immediately saw that with such subject matter Cubism could measure itself against the Old Masters on three important fronts, the genre portrait (as in the many figures with guitars, clarinets, etc.), the landscape and the still-life. Thus Cubism could properly be assessed as an alternative to classical perspective and declare itself a new version of realism. For this enterprise Braque provided poetic resources, and a craftsman's greater technical expertise. While Picasso digested Cézanne, Braque brought Chardin back into the game.

In his later years, the victim of the wounds and deprivations of two world wars, Braque continued on a more solitary road, exploring, with a devotion as cloistered as that of Cézanne in his Provençal retreat or Chardin in his grace-and-favour corner of the Louvre, the poetics of a world of familiar objects.

This particular musical arrangement acts as a prelude to a final series of epic interiors. Both in its colour scheme and in its central mandolin it can be read as a homage to Chardin and a free transcription of his masterpiece.

It also acts as Braque's farewell to the instrument as a central theme. Through the war years a skull would often replace it and eventually the artist's palette would take centre stage. With most painters it is fanciful to see ambiguities of intention in the forms they draw. With Braque however the idea of metamorphosis is an obsession

Jean-Baptiste Chardin (1699–1779), *The Attributes of Music*, 1765, oil on canvas. Louvre, Paris

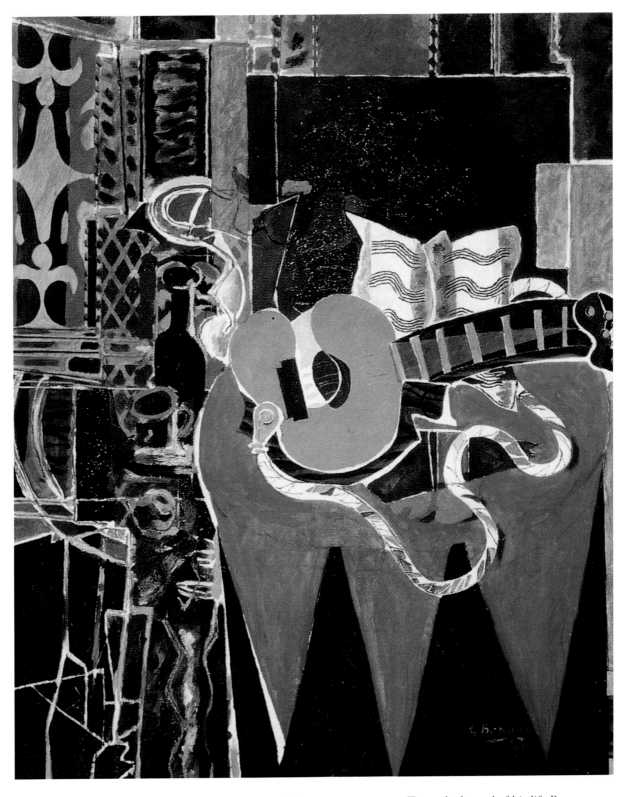

Georges Braque
(1882–1963)
*Mandolin with
Score (The Banjo)*
1941, oil on canvas
Private collection

he refers to repeatedly in statement and interview. To see the body of the mandolin hover between the curved sign of the artist's palette and a skull with its black eye sockets is to share Braque's sense of shifting identities. With one restless shape he announces his future themes and past preoccupations.

As if in tribute to Chardin's caprice of the curling sheets of music, Braque plays his own brilliant variation, but on a deliberately flattened plane. His score thus curves not with the illusion of bending paper but with the feeling of rolling staves whose sense of a lilting tune needs no notes.

Towards the end of his life Braque explained how his ordering of elements was an exercise in concentration. 'I am not a symphonist,' he declared, and indeed, in the literal sense, his dedication over half a century to the interior with still-life made him modern painting's most poetic master of chamber music.

Listening to Beethoven

The musical act that above all others is hardest to depict is that of listening. It would seem to be an elusive business, pretty much like doing nothing at all, until one thinks of the attitudes and attitudinising of one's neighbours in the concert hall. Leaving aside those inexplicable folk who pore over the programme notes while the music is going on (rather like reading slowly the names of the runners instead of watching the race), these can range from the theatrical souls whose main purpose is to let one know how profoundly moved they are, to the irritating experts who nod their head in time and anticipate events via a kind of miniaturised conducting. Others of course can be so engrossed that they seem virtually to have hibernated for the duration of the piece.

Fashion also plays a part. Here, separated by a couple of generations, are two small gatherings listening to the music of Beethoven. The first is multiply privileged in terms of talent and comfort, with genius six times present in the persons of Rossini and Paganini (standing together), Georges Sand, dressed as a man (sitting with Alexandre Dumas), Victor Hugo (behind them) and at the piano Franz Liszt, with his intellectual mistress Marie d'Agoult

serving more as a compositional element: she helps the eye drift from the shoulder of the composer's bust to the bottom of the picture and, via the carpet's border, into the almost bass-clef-like spiral of the faces and hands of the group.

Beethoven has been dead for thirteen years. Although such a concurrence of Romanticism's leading lights probably never took place, several of the group have personal memories of the composer, not least the invisible ninth artistic presence, the painter himself, who had covered the dead Beethoven's face with butter and plaster in order to make his death-mask. He used this in turn for the idealised bust we see on the piano. Now as a final act of piety he incorporates the bust into his painted homage.

A different sort of commitment inhabits Balestrieri's picture, whose scruffier band seems to have strayed (complete with Mimì) from the set of *La Bohème*, for an evening with the violin sonatas. Now in the late Romantic era angst has replaced exaltation. Eyes that were raised heavenwards or gazed into the infinite in Danhauser's painting are now cast down. Beethoven's message has changed: he has become a fellow tortured soul searching for life's meaning. His music is the first to

stare unflinchingly into the well of human suffering and one of the group seems almost suicidally to be staring down there with him.

Whatever attitude is taken or struck, Beethoven is its prime cause. He has been the crown of music's pantheon ever since Danhauser gave the original of the death-mask to Liszt. Felicitously a distant relation of that cast unites the two images. In the bare room of the bohemians it hangs on the rear wall, presiding over a curiously uneventful space. Beneath it lie some sheets of a score and below them nothing but an emptiness which we imagine to be vibrant with the sounds themselves. In both pictures the head of Beethoven provides the generative focus of the composition. Here, as if from the sun, the lines of force radiate from it, linking faces, limbs and objects: a simple metaphor for the composer's life-giving and all-embracing art.

Lionello Balestrieri (1874–1958), *Beethoven (Kreuzersonate)*, 1900, oil on canvas. Städelsches Kunstinstitut, Frankfurt/Main

Josef Danhauser (1805–45), *Liszt at the Piano*, 1840, oil on canvas. Staatsbibliothek, SMPK, Berlin

The Sound in My Life

A million years ago when man's ancestors stood upright in Africa (and began the whole adventure of making) the worlds of art, music and language were perhaps one thing. The mark made, the sound uttered or sung, even the step danced, were intimately linked. The history of this unity is lost although, as far as writing goes, we can piece together the development from drawing to script. The frequent liaisons, flirtations, affairs and marriages that are attempted between word and music and between those and the visual image (culminating in opera) celebrate that imagined past of perfect union.

My own work also betrays a nostalgia for this Eden before the roads of expression forked off in their various directions. The last of this sequence of fifty essays

must be, as politicians say, an appropriate moment to declare an interest.

As well as writing music that can be played I have often expressed the frustration of my technical limitations as a composer by drawing the music I aspire to make; a visual equivalent of the Lost Chord (Seated One Day at the Easel . . .). I love the way it looks as it compresses wonders into its economical code (in which paradoxically the great is virtually indistinguishable from the awful).

In the film *Song without End* (1960) the young Wagner arrives at the opera and presents Liszt (Dirk Bogarde) with what seems to be a single rolled sheet of paper. 'Would you do me the honour,' he asks, 'of looking at my Tannhäuser?' This must have been the microdot version, yet

the image stuck in my mind of a piece of paper charged with such density of sound whose objective form was a sequence of lines and blobs. This is mankind's greatest cryptographic achievement. As if in homage to that miracle I have bent those blind lines and with mute blobs have fashioned drawings which notate the sound outside my reach.

Around the mid seventies I had been reading about the last days of Schumann in the asylum at Endenich. The name Endenich itself with its sad derivable phrases and its harrowing absence of a redeeming final 't' had always fascinated me (. . . *Enden Ich, Ende Nich* . . .). Clara describes her husband's struggle to put down the unearthly music that he heard there. It seems that she destroyed

Tom Phillips (b. 1937), Pages from *A Humument*, 1966, book

Tom Phillips, *Last Notes from Endenich*, 1974, charcoal and conte on paper

these incomprehensible scraps of manuscript paper. This imagined music of delirium and its conjecturable wild orthography led me one day into a strange trance of drawing.

For perhaps the first time since childhood I found the marks coming unbidden and a structure forming itself unwilled. Even the accidental appearance of an 'A' at the beginning (i.e. far left) seemed to represent the constant tone that we know was tinitically dinned into the deranged composer's brain.

I called the drawing *Last Notes from Endenich* and it was published in a magazine as 'a score not intended for performance.' Its tenuous existence as a drawing and score, so nearly each and neither, provoked the French composer Jean Yves Bosseur to suggest that we collaborate on a version to be realised by his ensemble. It was his brilliant

intervention that brought Schumann's last actual surviving melody (which he had discovered on a visit to Endenich itself) into the dialogue of the work and made the whole enterprise poignant and possible.

I have revisited this shadowy no man's land between drawing and musical notation many times since and have made occasional transcriptions of real musical events (such as the motifs of the characters in the *Ring*). These are of course the result rather than the cause of what is played, yet they also witness that 'the sound in my life enlarges my prison'.

This phrase, which has become something of a motto for me, emerged from my working over (literally in both senses) a Victorian novel by W. H. Mallock, *A Human Document*. The resulting treated book is called *A Humument*. I have been working on it now for over

thirty years, forever replacing and revising its pages so that the version currently in print (2nd revised edition 1997) is only a distant relative of the first privately printed version. Over the years each page has slowly yielded its hidden treasure of words, and images have grown up around them.

Music, since it haunts my life, haunts also the texts and pictures of this work. When in 1969 I wrote a chamber opera called, after its heroine *Irma*, I used the book as a source for the libretto and it also provided the poems for a song sequence *Six of Hearts* in 1995.

Just as *A Humument* occupies the strange vacant lot between word and image so have my drawings annexed the neighbouring underdeveloped site between music and art whose rich and resonant relationship this series of essays has set out to explore.

List of Illustrations

Johann Nepomuk della Croce
The Mozart Family Portrait
1780–81. oil on canvas
Mozart Museum. Salzburg
see p. 94

Max Oppenheimer
The Klinger Quartet
1916. oil on canvas
Austrian Gallery. Vienna
see p. 49

Leonid Pasternak
*Prokofiev at the Soviet
Embassy, Berlin*
1937. oil on canvas
Glinka Museum. Moscow
see p. 104

Tom Phillips
Pages from *A Humument*
1966. book
see p. 120

Tom Phillips
Last Notes from Endenich
1974. charcoal and conte
on paper
see p. 121

Pablo Picasso
Violin: 'Jolie Eva'
1912. oil on canvas
Staatsgalerie Stuttgart
see p. 83

Pablo Picasso
Violin (Violon)
1912. collage
Picasso Museum. Paris
see p. 88

Pablo Picasso
Violin (Violon)
1913–14. cardboard box.
pasted paper. gouache.
charcoal. chalk on cardboard
Picasso Museum. Paris
see p. 88

Pablo Picasso
Portrait of Igor Stravinsky
1920. drawing
Picasso Museum. Paris
see p. 9

Piero della Francesca
The Nativity
c.1470. oil on panel
National Gallery. London
see p. 71

Cornelis Van Poelenburgh
Nymphs and Satyr
c.1630. oil on canvas
Dulwich Picture Gallery.
London
see p. 57

Nicholas Poussin
A Dance to the Music of Time
(detail)
c.1639–40. oil on canvas
Wallace Collection. London
see p. 52

Ivan Puni
Synthetic Musician
1921. oil on canvas
Landesmuseum Berlinische
Galerie. Berlin
see p. 14

Raphael
St Cecilia with Attendant Saints
1513–16. oil on panel
Pinacoteca. Bologna
see p. 29

Rembrandt van Rijn
David and Saul
c.1658. oil on canvas
Mauritshuis. The Hague
see p. 67

Pierre Auguste Renoir
Young Girls at the Piano
1892. oil on canvas
Musée d'Orsay. Paris
see p. 31

Pierre Auguste Renoir
*Yvonne and Christine Lerolle
at the Piano*
1897. oil on canvas
Musée de l'Orangerie. Paris
see p. 30

*The Ring, Götterdämmerung,
Das Rheingold*
Drawings by Gil Kane
Colouring by Jim Woodring
Lettering by John Costanza
Story adapted by Roy Thomas
Publisher: DC Comics
see p. 68

Albert Pinkham Ryder
*Siegfried and the Rhine
Maidens*
1888–91. oil on canvas
National Gallery of Art.
Washington. DC
see p. 69

Carlo Saraceni
St Cecilia and the Angel
1610. oil on canvas
Galleria Nazionale d'Arte
Antica. Rome
see p. 76

Saverio dalla Rosa
Wolfgang Amadeus Mozart
1770. oil on canvas
Mozart Museum. Salzburg
see p. 94

Julius Schmid
*A Schubert Evening in a
Vienna Town House*
1897. oil on canvas
Historical Museum of the City
of Vienna
see p. 34

Arnold Schoenberg
Portrait of Alban Berg
c.1910. oil on canvas
Historical Museum of the City
of Vienna
see p. 65

Walter Richard Sickert
*Sir Thomas Beecham
Conducting*
1938. oil on burlap
Museum of Modern Art.
New York
see p. 87

David Smith
Budapest String Quartet
1946. oil on paper mounted
on masonite
Smith Foundation
see p. 48

Harmen Steenwyck
*Still Life: An Allegory of the
Vanities of Human Life*
c.1640. oil on oak
National Gallery. London
see p. 46

Patrick Symons
Cellist Practising
1969–71. oil on canvas
Browse & Darby. London
see p. 106

Ludwig Tersch ('Lucky')
Entartete Musik
1938. poster-cover
Paul Hindemith Institute.
Frankfurt/Main
see p. 92

Jean Tinguely
& Niki de Saint Phalle
Stravinsky Fountain
1983. aluminium. fibreglass
and polyester
Centre Pompidou. Paris
(outside)
see p. 62

Titian
Venus and the Organ Player
c.1548. oil on canvas
Prado Museum. Madrid
see p. 110

Titian
*Reclining Woman
with Lute Player*
c.1550. oil on canvas
Fitzwilliam Museum.
Cambridge
see p. 110

Titian
*Reclining Woman
with Organist*
c.1550. oil on canvas
SMPK. Berlin
see p. 111

Titian
The Flaying of Marsyas
1570–75. oil on canvas
Archbishop's Palace. Kromeriz
see p. 25

Michele Todini
Harpsichord
c.1675. gilded wood
Metropolitan Museum of Art.
New York
see p. 108/109

Henri de Toulouse-Lautrec
Jane Avril: Jardin de Paris
1893. lithograph in four
colours
Delteil 345
see p. 80

J. M. W. Turner
Music Party at Cowes Castle
c.1827. oil on canvas
Tate Gallery London
see p. 16

Jan Vermeer
*Music Lesson (A Lady at
a Virginal with a Gentleman)*
c.1662-64. oil on canvas
The Royal Collection.
Windsor Castle
see p. 101

Jan Vermeer
*A Young Woman Seated
at a Virginal*
c.1675. oil on canvas
The National Gallery. London
see p. 100

Paolo Veronese
Marriage at Cana
1563. oil on canvas
Louvre, Paris
see pp. 50/51

Jean-Antoine Watteau
Les Plaisirs du Bal
c.1717. oil on wood
Dulwich College. London
see p. 16

Piotr Williams
Portrait of Shostakovich
1947. oil on canvas
Glinka Museum. Moscow
see p. 105

David Wynne
Sir Thomas Beecham
1957. bronze
National Portrait Gallery,
London
see p. 86

Johann Zoffany
*The Sharp Family: A Musical
Party on the Thames*
1780. oil on canvas
National Portrait Gallery.
London (on loan from
a private collection)
see p. 114

*Playing John Cage at the
Warsaw Festival in 1975*
Photo WF Archive
see p. 102

Bronze chimes with stand
(reconstructed)
China (Eastern Zhou.
5th century BC)
Museum of the City of Suizhou.
Hubei Province. China
see p. 42/43

Drummer (Singing Storyteller)
China (Eastern Han. 25–280 AD)
Painted terracotta
Museum of Sichuan Province,
China
see p. 42

Cycladic
Idols
c.5000–4000 BC
N. C. Goulandris Foundation.
Museum of Cycladic Art.
Athens
see p. 22

Cycladic
Seated Figure with Harp
c.3000 BC. marble figure
Metropolitan Museum of Art.
New York
see p. 23

Hands of a harpist: fragment
from tomb. Valley of the Kings
Egypt (c.1305–1080 BC)
see p. 66

Preparations for a Concert
Greco-Roman fresco from
Stabiae. 1st century AD
Museo Nazionale. Naples
see p. 77

*Orpheus Charming
the Animals*
Roman mosaic. 2nd century AD
Lapidary Museum. Vienna
see p. 52

Unknown artist
Lyre
19th century. mixed materials,
found Nuba Hills, Sudan
British Museum. London
see p. 53

Unknown Azande artist. Zaire
Mbira (thumb piano)
c.1890. wood with bamboo
keys and attachments
Royal Museum of Central
Africa. Tervuren. Belgium
see p. 33

Unknown Makonde artist.
Tanzania/Mozambique
Drum (likuti)
late 19th or early 20th century
wood. leather. hair. copper
nails
W. and U. Horstmann
Collection. Switzerland
see p. 17

Unknown Fante artist. Ghana
Drum
c.1940. wood
Private collection. Paris
see p. 32

Unknown artist.
from Guinea-Bissau
Guitar
oil can. wood and wire
Livesey Museum. London
see p. 108

Index of Names

Photographic Credits

DATE DUE

SEP 0 5 2001		
NOV 2 2 2008		
GAYLORD		PRINTED IN U.S.A.